John Murdoch

Forty two British watercolours from the Victoria and Albert Museum

Phoenix Art Museum, Phoenix, Arizona
Utah Museum of Fine Art, Salt Lake City
Fine Arts Gallery of San Diego, California

Art Gallery of Ontario. Toronto
National Gallery of Canada, Ottawa
Art Gallery of Greater Victoria, Victoria,

London 1977

Acknowledgement

On behalf of the participating North American institutions, I would like to thank Roy Strong, Director, Victoria and Albert Museum and C Michael Kauffmann, Keeper of the Department of Prints & Drawings and Paintings, for their cooperation with the arrangements for this exhibition. Thanks must be given to John Murdoch, Assistant Keeper of the Department of Paintings, who selected the paintings to be included and produced this catalog.

Robert H Frankel
Assistant Director
Phoenix Art Museum
Phoenix, Arizona

Printed in England for Her Majesty's Stationery Office by Ebenezer Baylis & Son Ltd, Leicester and London Dd 327383

Foreword

This exhibition owes its origin to the enthusiasm of Mr Robert Frankel of the Phoenix Art Museum who first asked us to prepare it and to send it across the Atlantic. The plan came to fruition through the strongly expressed interest of the other borrowing Institutions.

The Victoria and Albert Museum contains, among its many riches, the national collection of British watercolours and it is from this collection that the present selection has been made. All the major artists are represented, many of them by the Museum's masterpieces, as well as some of the less well-known names which have been chosen both to provide a dimension of the unexpected and to ensure that different trends in British watercolours are fully and clearly displayed.

Selection of exhibits and catalogue alike are the work of John Murdoch, Assistant Keeper in the Department of Paintings. The catalogue entries incorporate the results of his recent research and will, it is hoped, be of interest to the specialist as well as providing insight for the enjoyment of the general visitor.

C M Kauffmann
Keeper
Department of Prints & Drawings
and Paintings

1 Charles Collins
1680?–1744
The Greater Loon

Bodycolour and transparent watercolour on white laid (w/m illegible); 54·5 × 37·3 cm. The paper browned and foxed.
Signed lower left *recto* in ink: *Cha. Collins Fec.* | *Decem.ʳ 1740* (the 'e's reversed); and inscribed lower right in pencil: *26*; *verso* by the artist(?) in pencil: *The Greater Loon. Columbus Major | aldrov. 2v.339*, and by another hand: (?) *Female | Gt Crested | Grebe.*
PROVENANCE Presumably Taylor White FRS, sale Sotheby's, 16 June 1926, lot 657A; Lady Duckworth, from whom purchased, May 1929. P.138-1929
LITERATURE M Hadrie, *Watercolour Painting in Britain*, 1966, I, 67. See also J G T Graesse, *Trésor de Livres Rares et Précieux*, 8 vols, Dresden 1859, I,65; and Jean Anker, *Bird Books and Bird Art*, Copenhagen 1938. The date of Collins' birth, unsupported by evidence, is given by Walter Gilbey, *Animal Painters of England . . .* 1900, I, 102.

Charles Collins' large bodycolour drawings of birds were hardly known until 1926 when the sale of Taylor White's volumes took place at Sotheby's. Samuel Redgrave in 1876 referred only to the series of 12 hand-coloured engravings by H Fletcher and J Mynde after Collins, showing 58 species, published by Collins and John Lee in 1736. This set is in the British Library; another, published by the entrepreneur Thomas Bowles, is in the University Library, Copenhagen (Anker no. 105).

Unfortunately, we have little detailed knowledge of the Taylor White collection. The sale catalogue mentions 16 volumes containing 659 drawings of song and game birds by Collins and P Paillou, 6 volumes of beasts from the New World, Africa and India

(265 drawings all by Collins) together with 22 fishes and crocodiles and 21 fungi by Collins and Eleazar Albin. The volumes were broken up in the trade, and a number of the birds appeared again for sale in 1931 at E Parsons' shop in Brompton Road priced at around £1 each. According to F W Stokes (ms. note in Museum records) they were dated between 1737 and 1741, that is *after* the publication of the Fletcher-Mynde engravings. The likelihood is that the Taylor White volumes, bound in 'old half calf', originally came from the study collection of an English natural historian, who may have intended to publish the drawings to illustrate a comprehensive Natural History.

The inscription on the back of the present drawing indicates the scientific and bibliographical context of the work. The reference *aldrov.* is to Ulissi Aldrovandi (1522–1605), the Bolognese naturalist whose *Ornithology*, in three volumes (1599, 1600 and 1603) formed the first part of an encyclopaedic description and analysis of the whole field of natural history. The *Ornithology*, illustrated by wood engravings by Christoforo and G B Coriolano after original drawings commissioned by Aldrovandi, was reprinted in Frankfurt and Bologna in 1610–30, 1637, 1646, 1652 and 1683. Towards the end of the seventeenth century it began to be superseded by the work of English ornithologists, particularly Francis Willughby and John Ray (*Ornithologiae Libri Tres*, 1676, which had an important influence on the systematic ornithology of Linnaeus) but Aldrovandi remained an easily accessible source of detailed illustration. In scale and style, Collins' drawings owe much to Aldrovandi, a fact which sets him apart from his younger

contemporary George Edwards (1693–1773), whose *Natural History of Birds*, 1743-51, was the major work of English ornithological science in the middle of the eighteenth century. Although Edwards may thus have pre-empted any plans for the further publication of Collins' drawings (some of the illustrations in Pennant's *Zoology* are derived from Collins), Collins emerges as the finer draughtsman in the long tradition of scientific illustration. Since the Renaissance the artist had been by no means isolated from the broad stream of scientific activity, and especially in the era before taxidermy and photography, the skills of the artist were essential tools of serious enquiry. Stubbs' anatomical drawings are just the best known, and probably the most beautiful eighteenth-century products of an essential identity of purpose between 'artists' and 'scientists' – the study and penetration of the mysteries of existence.

The subject of the present drawing is thought to be a Great Crested Grebe, either a female or an immature male. The term 'Greater Loon' is apparently more usually associated with the Great Northern Diver (*Columbus glacialis*), but in the eighteenth century it applied equally to the Great Crested Grebe: the divers and grebes were not regarded as separate *genera* by authorities up to and including Thomas Pennant (*British Zoology*, 1768, II, 339n.). Aldrovandi's treatment of the subject 'De Colymbis Majoribus', including two 'crestatus' types, is at Book XIX Head LII (ed. 1637). The reference given by Collins may be to the 1683 edition.

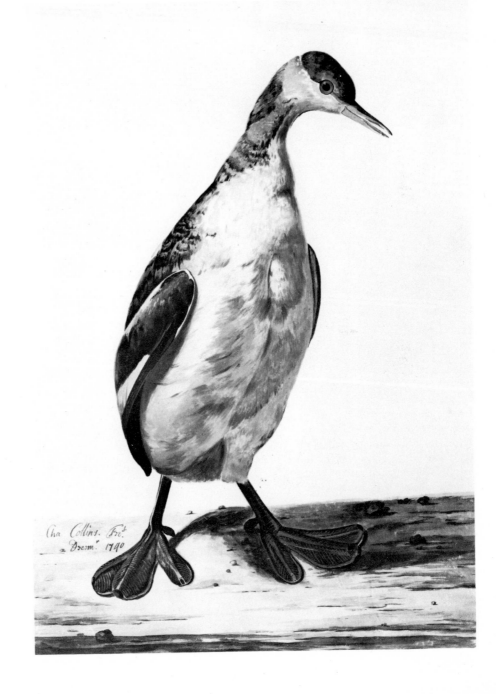

Cha Collins. Pixt.
a Dream.ʳ 1790

2 Francis Cotes
1726–1770
Purley Hall, Berkshire

Pen and watercolour, on white laid;
37·1 × 53·7 cm. The wash mount is modern.
Signed and dated in pencil lower right:
F. Cotes del^t / 1756=.
PROVENANCE Purchased from Walker's
Galleries, December 1932. P.35-1932
EXHIBITED Nottingham, 1971, *Introducing
Francis Cotes R.A.*, no. 42, pl. 16.
LITERATURE E M Johnson, *Francis Cotes*,
1976, pp. 14, 158, and no. 71; fig. 25.

The house was not identified until 1956, when
Derek Sherborn of the National Buildings
Record recognized it as Purley Hall, seat of
Francis Hawes. Hawes, a director of the
South Sea Company, had ordered statuary
and ornament to the value of £128 for the
gardens from Andries Carpentière in 1720;
some of this is presumably visible in the
present drawing. Cotes, of course, was already
an established portrait painter in oil and
pastel by 1756, but this is the only landscape
by him in pen and wash that is still extant.
In style and subject, drawings such as this
were generically the product of French and
Dutch influences, but by the middle of the
eighteenth century, the tradition was well
established in England and had become a
distinctive local manifestation of the
international rococo.

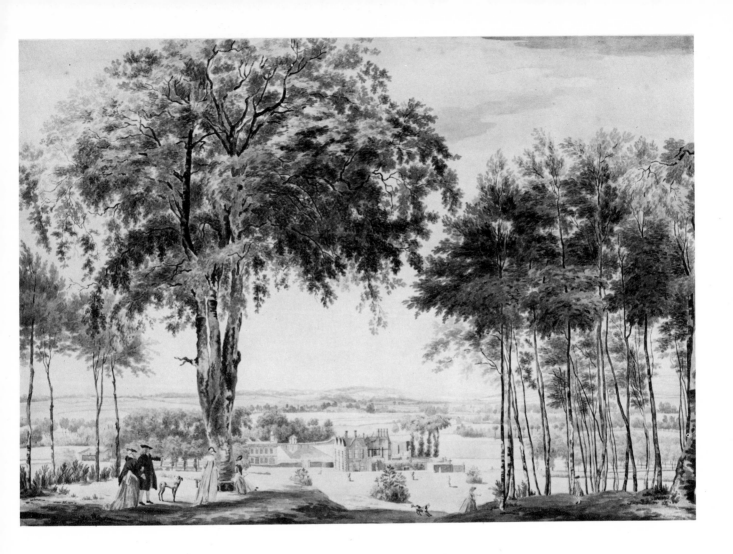

3 Thomas Gainsborough
1727–1788
Landscape with Cottage and Stream

Pencil and black chalk with wash and some gouache, on white laid; 30·5 × 36·7 cm (sheet size); double ruled in ink as a mount but subsequently trimmed to about 2 mm over work area.

Inscriptions etc: Initials of William Esdaile in ink lower right *recto*; *verso* inscribed by Esdaile in ink: *(. . . WE) G- Frost's colln N50 X* (the early part obscured by old glue and paper).

PROVENANCE George Frost; William Esdaile; his sale, Christie's, 20–21 March 1838; Rev Alexander Dyce, by whom bequeathed to the Museum, 1869. D.676

LITERATURE J Hayes, *The Drawings of Thomas Gainsborough*, 1970, I, no. 153, pp. 34, 147–8; II, pl. 42.

Drawings by Gainsborough have often had a long hard life. Jackson recalled that he (Gainsborough) once 'presented 20 drawings to a lady who pasted them to the wainscot of her drawing room' as the fashion was to paste prints. Even Dr Monro, undoubtedly a serious collector and patron, used to stick unmounted drawings to his walls, nailing strips of gilded beading around them to simulate frames. But drawings suffer also from more conventional modes of keeping and display, the present example having been worm-eaten in its frame and stained by exposure to light over many years. Such damage is the sad evidence of too much love, and Gainsborough's appeal to the collectors – as an inventor of compositions and as a marvellous graphic technician – has always been overwhelming.

His importance to the wider world in fact grows quite narrowly out of his relations with the connoisseurs and 'aesthetes' of the period. It was connoisseurs like Uvedale Price (an acquaintance or friend of Gainsborough in Bath), Payne Knight and William Gilpin who formulated the literary and pictorial aesthetic of the Picturesque, and Price at least was explicit in acknowledging his debt to Gainsborough. These critics cited artists of the Dutch, Flemish and Italian schools in support of their arguments, but it is probably true that no artist was more fully representative, more fully an exponent of the Picturesque, *avant la lettre*, than Gainsborough. The present drawing could stand as a polemical passage of Price, or have inspired a carefully contrived view in Knight's park at Downton: dating from the 1750s (according to John Hayes) it leads unmistakably into the romantic landscape of the nineties and the first quarter of the new century.

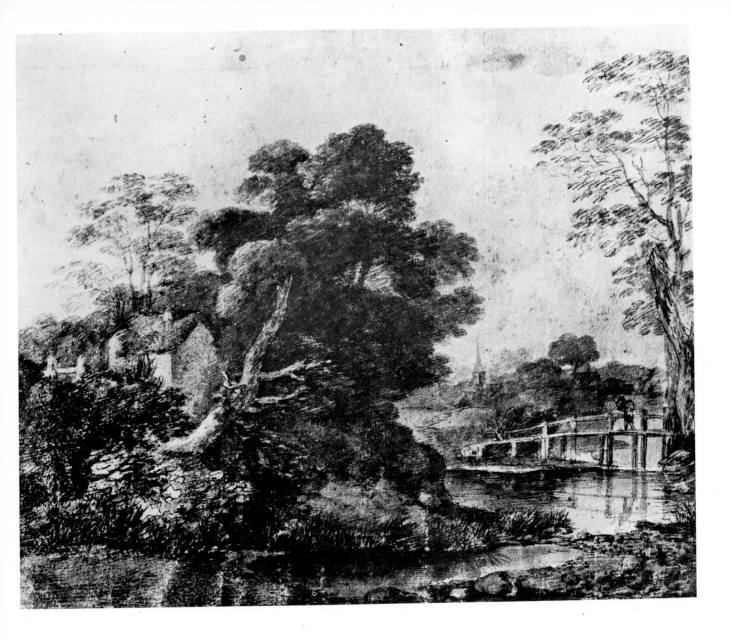

4 Paul Sandby
1730–1809
Three daughters of the 2nd Earl of Waldegrave, with Miss Keppel

Watercolour over pencil on thin white laid; 13 × 18·3 cm, stuck by the corners to a thicker sheet.

Inscribed in pencil with numerals 1–4 beneath the figures of juveniles, and on the mounting sheet (*recto*):

1 Miss Keppel Daughter to the Bishop of Exeter
2 Lady Laura Walgrave
3. Lady Horatia Walgrave
4 Lady Maria Walgrave

'de' is added by the same hand above the word 'Walgrave' in each case. There are additional, late inscriptions on the *verso* of the mount and on a label preserved with the drawing, but these are not compatible with the old inscription, which may be by Paul Sandby himself.

PROVENANCE Bequeathed by W A Sandby, 1904. D.1835–1904

LITERATURE A P Oppé, *The Drawings of Paul and Thomas Sandby . . . at Windsor Castle*, 1947, pp. 49, 71.

There has been difficulty about the identification of the figures in this drawing which must rest on the old inscription quoted above. The daughters of the 2nd Earl of Waldegrave (he had married, 15 May 1759, as his second wife, Maria Walpole, the illegitimate daughter of Sir Edward Walpole by Dorothy Clementi, a milliner's apprentice) were:

Elizabeth Laura, b. 1760, who married her cousin George, 4th Earl of Waldegrave, 5 May 1782. She is no. 2 in the drawing.
Charlotte Maria, b. 1761, who married George Henry, Earl of Euston and 4th Duke of Grafton, 16 November 1784. She is numbered 4.
Anna Horatia, b. 1762, who ultimately married

Lord Hugh Seymour, and is numbered 3 in the drawing.

The Miss Keppel should correctly be the eldest daughter of the Bishop, the Honourable Frederick Keppel, and she was Anna Maria, b. 1759, and a cousin of the Waldegrave girls. Her mother Laura was the elder sister of Maria, the Countess Waldegrave, both of whom have been speculatively suggested for identification with the adult figure in the drawing.

The date would be in the late sixties or very early seventies.

A related study is at Windsor (Oppé no. 296). This shows Anna Maria Keppel with Lady Elizabeth Laura and Lady Charlotte Maria Waldegrave. It is inscribed *Lady Waldegraves* between the two latter figures. Oppé's discussion of the subject of the Windsor and VAM drawings is faulty as to identification, but he points out that the figures recur in several finished compositions: 'The two elder girls recur in a group in the aquatint, "The North Terrace looking Westward" of 1776; while the third appears, together with a lady resembling the governess [i.e. the adult] . . . in the "Old Somerset House" by Thomas Sandby . . . The whole group, as in the drawing in the Victoria and Albert Museum, reappears in a "North Terrace looking East" . . .' (p. 71). The drawing is thus only partly portraiture. The main purpose of it and the numerous other figure studies that Sandby accumulated was, as with those of Luca Carlevaris for example, to provide a repertory of lively and variously employed mannikins for the finished *vedute*. They help to show how intimately connected to the general European, and here more specifically the Venetian traditions, the rise

of English landscape painting was in the eighteenth century.

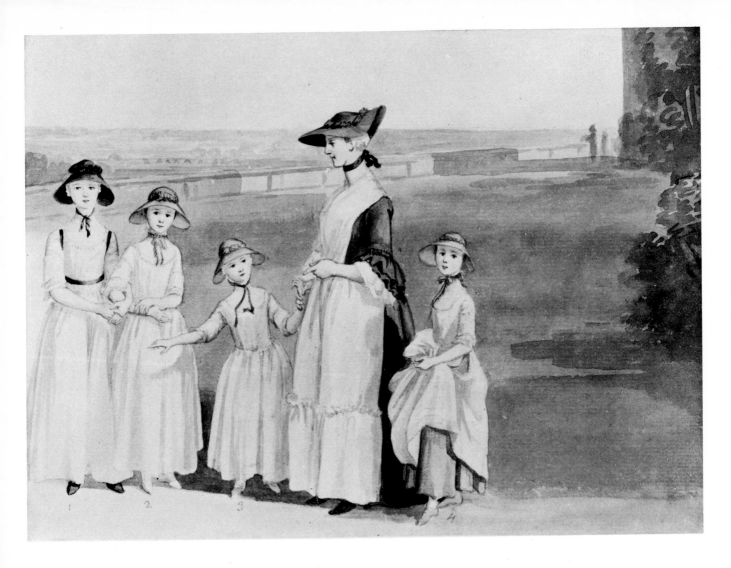

5 Paul Sandby
1730–1809
Windsor Castle: the North Terrace looking West

Bodycolour on laminated laid paper;
38 × 53·5 cm.
Signed and dated lower right (on the
parapet): *P Sandby 1800.*
PROVENANCE Bequeathed by W A Sandby,
1904. D.1832–1904
LITERATURE A P Oppé, *The Drawings of
Paul and Thomas Sandby . . . at Windsor
Castle,* 1947, pp. 20–1, nos. 4 and 5.

This is a very late version by Sandby of the
North Terrace view which he took originally
some time about 1770, and aquatinted for
publication in his *Five Views of Windsor
Castle and Eton* of 1776–7. According to Oppé,
the buildings are the west end of Queen
Elizabeth's gallery, Winchester Tower, the
Canons' houses (at the far end of the terrace),
and Clewer Church in the valley of the
Thames, with the hills beyond Maidenhead
rising in the distance. The costume of the
figures makes some concession to the changes
in fashion between the seventies and the new
century, but for them (as for the buildings)
Sandby relied on his old sketchbooks: the
soldier on the parapet to the right, for
example, is culled from the same (lost) study
as the seated soldier in a drawing at Windsor
of the gardens at Old Somerset House
(Oppé no. 161).
 Sandby had a powerful and pervasive
influence on the draughtsmen of his day, and
he was easily the most accomplished English
artist working principally in watercolours.
Stylistically and technically, especially when
working in gouache, he had the assurance of a
properly trained European painter, and
contributed thus to the rising prestige of
watercolour as an exhibition medium. In
addition, his early work in Scotland, his tour
in Wales, his work in the park at Windsor,
and his lifelong co-operation with his brother,
the architect Thomas Sandby, relate him
significantly to the main areas of Picturesque
interest before 1800. His drawings provided
one of the ways in which Picturesque
aesthetics reached a non-reading audience.

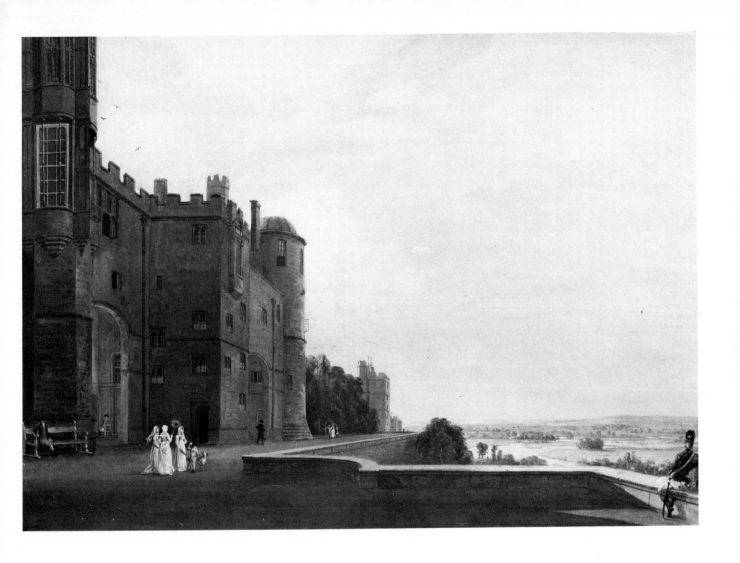

6 John Cleveley
1747–1786
The Ships of Commodore Phipps' Expedition, embedded in the Ice at Spitzbergen, August 1773

Pen and ink and watercolour, on white laid
(w/m J Whatman with the Strasbourg Lily);
36·5 × 46·5 cm.
Signed in ink lower left: *Jnᵒ Cleveley Junʳ
Delint. 1774.*
PROVENANCE J Hogarth and Sons, from
whom purchased by the Museum, March 1887
EXHIBITED Possibly RA, 1774, no. 41, 'Two
of the racehorse and Carcass in the ice at
Spitzbergen; companions, tinted drawings.'
316–1887
LITERATURE I Williams, *Early English
Watercolours*, 1952, p. 200; M Hardie,
Watercolour Painting in Britain, 1966, I,
p. 235, pl. 238; see also C J Phipps, *The
Journal of a Voyage undertaken by order of his
present Majesty, for making discoveries towards
the North Pole, by the Hon. Commodore Phipps,
and Captain Lutwidge, in his Majesty's sloops
Racehorse and Carcase . . .*, 1773; and
*A Voyage towards the North Pole undertaken
by His Majesty's command, 1773 . . .*, 1774,
with plates by P C Canot, W Byrne et al.
after Cleveley.
Related drawings for the illustration of the
Voyage are in the British Museum and
National Maritime Museum.

Cleveley was a beneficiary of the wide
availability of instruction in drawing during
the second half of the eighteenth century. He
was brought up as an artisan in the shipyards
of Deptford, and was taught drawing by
Paul Sandby, who was the chief drawing
master at the Military Academy of Woolwich
between 1768 and 1796. Through Sandby,
Cleveley met Sir Joseph Banks (1743–1820),
the President of the Royal Society and *doyen*
of British natural historians. Banks took
Cleveley as official draughtsman on his voyage

of 1772 to the Orkneys and Iceland, and the
next year Cleveley was appointed in a similar
capacity to accompany the expedition of
Constantine Phipps,* the primary objective
of which was to 'make discoveries towards the
North Pole'. The voyage, though it failed to
penetrate the ice-flows of Spitzbergen, was
evidently of considerable importance:
Phipps' journal was published in 1773,
re-printed in 1774, and a formal account of
the expedition, with illustrations after
Cleveley's drawings, also came out in 1774.
These were followed by an Irish edition
(1775), a French translation (Paris 1775), and
a German (Bern 1777). This by no means
completes the bibliography of the *Voyage*,
but suggests that the usual description of it
as a total failure (in its alleged purpose of
discovering a northerly route to India),
notable only for the presence on the *Carcass*
of Midshipman Nelson, was not supported
by contemporary opinion.

Cleveley's drawings were not of course
scientific studies in themselves, nor was the
greater part of his *oeuvre* concerned with
exploration. His work for Phipps was
primarily *reportage*, and its function, whether
published on the walls of the Academy or
reproduced in editions of the *Voyage*, was to
inform people of the activities of exploratory
science. Such drawings, and paintings by
major artists like Hodges, were products of
interest in the unknown and challenging,
and were representative of a tradition in art
that stretched back unbrokenly to the
Renaissance.

* The Hon. Constantine John Phipps (1774–1792),
became 2nd Baron Mulgrave of New Ross in the
Irish peerage, and was created Baron Mulgrave
in the peerage of Great Britain in 1790. He was a
Fellow of the Royal Society and of the Society of
Antiquaries.

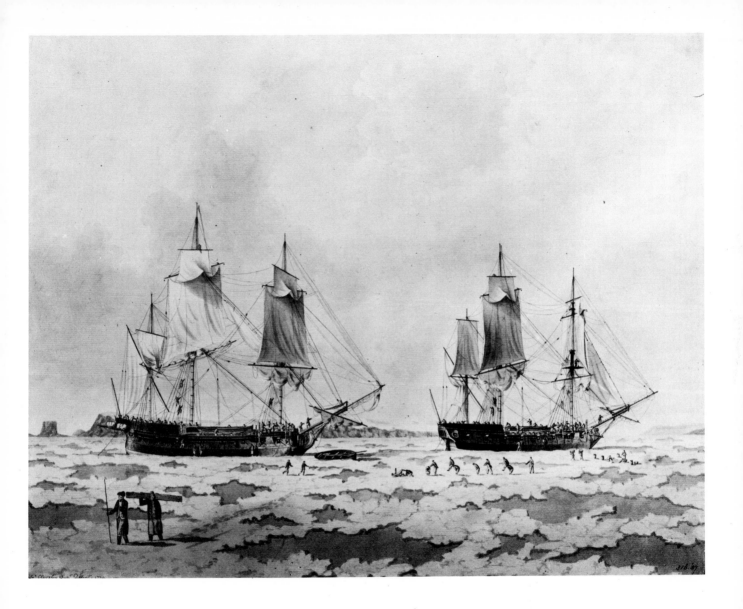

7 Phillip J de Loutherbourg
1740–1812
The Montagne

Pen and ink and watercolour on white laid (w/m J. Whatman) silhouetted on the left and pieced out with white laid; put down on white wove (w/m J. Whatman); 48.6×31 cm. The primary sheet marked with folds, patched in the upper edge; engrimed and faded.

Inscribed in pencil, upper right: *the Ship 13 – high | the mast 54in high*; and in ink lower right: *The Main Mast to be half the breadth | in a midships.* Stamped *verso* with the mark of Dr John Percy.
PROVENANCE Dr John Percy; his sale, Christie's, 23 April 1890, lot 1126, bt Vokins on behalf of the Museum. 195–1890

This drawing was attributed by Dr Percy to J T Serres (who was much influenced by de Loutherbourg) and this view has been accepted ever since. The drawing has, however, now been recognized by E H Archibald of the National Maritime Museum, as a study for de Loutherbourg's *Battle of the Glorious 1st of June 1794* (NMM). The subject is the French ship *Montagne* sailing ahead while she fights the flagship of Lord Howe, *Queen Charlotte*, at about 10 o'clock on the morning of the battle. *Queen Charlotte* eventually forced the retirement both of *Montagne* and of *Jacobin*, the next in the French line. The painting was begun as a pendant to the military *Battle of Valenciennes*, soon after the news of Lord Howe's victory reached England, and was shown continuously for three years after 1795 at the Historic Gallery in London. A drawing for the whole composition, but with *Montagne* left in a very sketchy state, is in the British Museum. It is clearly by the same hand as the VAM drawing, and

the inscriptions, which variously identify the ships and provide a memorandum for scaling the drawing up to the picture size, are also certainly in the same handwriting.

As with the Cleveley drawings of the Phipps expedition to the Arctic, de Loutherbourg's pictures were a form of reportage, a way of bringing before the public, at the height of demand, a vividly realized account of the great contemporary events. This is one of the most important aspects of romantic art, in painting as in literature: its successful commercial opportunism, and the extent to which great artists – painters and writers – were willing to use occasional and ephemeral media with the utmost seriousness.
De Loutherbourg illustrating the great naval victory is in a sense a parallel of Walter Scott writing for the *Annual Register*; and de Loutherbourg's show in the Historic Gallery grew naturally out of his work as scene painter at the Theatre Royal, Drury Lane.

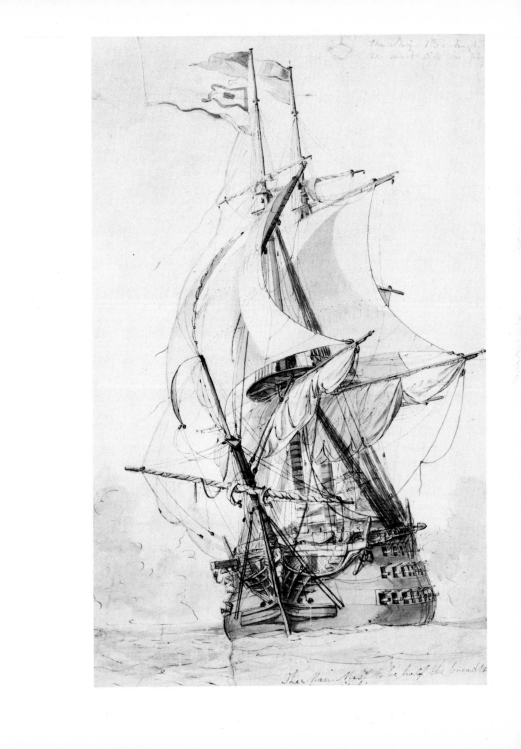

8 S H Grimm
1733–1795
The Macaroni

Pen and ink, and watercolour (the woman talking to the *beau* in the left background has been repainted wholly in gouache) on white laid; 17·4 × 14·7 cm.
Signed in ink, lower left *recto*: *S. H. Grimm fecit 1774.*
PROVENANCE Agnew's, from whom purchased 1939. P.39–1939
EXHIBITED Agnew's, 66th *Annual Exhibition of Watercolour and Pencil Drawings*, no. 187, as 'The Masher'.
LITERATURE R M Clay, *Samuel Hieronymous Grimm of Burgdorf in Switzerland*, 1941, p. 48.

The Agnew title arose presumably in the nineteenth century. In the 1770s the word was certainly *macaroni* rather than *masher*, and it derived, according to OED, 'from the name of the Macaroni Club, a designation probably adopted to indicate the preference of the members for foreign cooking, macaroni being at that time little eaten in England'. More generally, the term was applied to exquisite and over-dressed people 'who had travelled and affected the tastes and fashions prevalent in continental society'. Samuel Johnson, correctly recognizing the tendency of élite groups to distinguish themselves by accent or syntax, put the emphasis on speech. He connected the term with *macaronick* verse – invented by Teofilo Folengo (1491–1544) in his *Liber Macaronicus* – 'in which the language is purposely corrupted' by the grotesque intermingling of two or more languages (*Dictionary*, 1773). And the *Oxford Magazine* in June 1770 noticed 'a kind of animal, neither male nor female, a thing of the neuter gender, lately started up amongst us. It is called a Macaroni. It talks without meaning,

it smiles without pleasantry, it eats without appetite, it rides without exercise, it wenches without passion.'

The macaronies were marvellous subjects for the satiric draughtsmen and print-makers, particularly Dighton, Dixon, Gillray, Bunbury, etc., who made much of the characteristic macaroni costume. Richard Cosway, the miniature-painter, was himself a prominent macaroni: 'full-dressed in his sword and bag; with a small three-cornered hat on the top of his powdered toupée, and a mulberry sik coat, profusely embroidered with scarlet strawberries' (see F G Stephens, *Catalogue of . . . Personal and Political Satires 1761–1774*, British Museum, 1883).

Grimm's drawing here is so sharp and differentiated in character, that it could be a portrait. R M Clay (ms. letter) suggested the 3rd Duke of Queensbury, but I think the suggestion is groundless. Queensbury's theatrical connections place him in the right ambience, but he was grotesque neither in body nor dress. Possibly, however, the drawing was merely a re-working and development of a general idea originally entertained by Grimm as a contribution to the series of Macaroni prints dated 1772 (see Stephens, 1883, nos. 4601–4604).

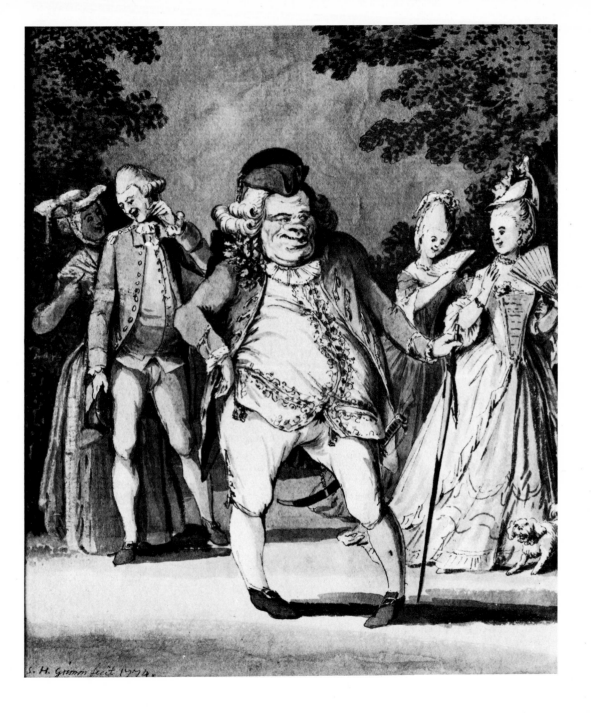

S. H. Grimm fecit 1774.

9 S H Grimm

1733–1794
A Remarkable Chasm

Pen and ink and watercolour on white laid;
25·3 × 19·2 cm (sheet size) put on to the page
of an album (w/m a truncated Strasbourg
Lily).
Inscribed in ink on the album page: *This
remarkable Chasm is cut by the Rains in a
perpendicular Wall of Rock of an amazing
highth in the road from Macyleth to Dolgelly –
probably the Cascade is wanting in very dry
seasons*, and numbered: *(57)*.
PROVENANCE From an album of views by
Grimm sold Sotheby's, 18 December 1918,
lot 399, bt Rimell (£34), who resold it in parts
to dealers including F R Meatyard of
Museum Street; bought (with three others
by Grimm) 1920. P.97-1920

The album from which the *Remarkable Chasm*
came was, according to A P Oppé (ms. letter
in Museum records) made up of about 20
views in Switzerland (dated 1775, when
Grimm was living in England), and a number
of views on the Thames. The rest seem to
have been Welsh. Grimm's work on the
topography of Wales derived from the tour
he made with H Penruddocke Wyndham, a
friend of Gilbert White of Selbourne, in
June–August 1777. Wyndham was working
on the second edition of his *Tour through
Monmouthshire and Wales . . .* (1st edition
1775; 2nd expanded edition 1781), for which
Grimm supplied illustrations. It is reasonable
to suppose that the present drawing was
made from a sketch taken on this tour, but
not used by Wyndham;* on the evidence of
the terms on which Grimm was hired by

* Wyndham made up an extra-illustrated copy of
the *Tour* which is now in the National Library
of Wales.

Gilbert White, at a flat weekly rate to supply
drawings, it is also likely that the *Remarkable
Chasm* became Wyndham's property, and
was bound by him into the album.
 Wyndham was not one of the best of the
early tourists in Wales. He was not as
observant nor as scholarly as Thomas Pennant
(who employed the draughtsman Moses
Griffith to illustrate his *Tour*), but his
association with Gilbert White, and through
him with Pennant, establishes him as a figure
in the English circle of systematic naturalists
and antiquarians who cultivated the faculty
of exact observation as the foundation of their
scientific method. The draughtsmen they
employed were required to match the precision
of their patrons, and something of this mental
habit is hinted at in the inscription to the
present drawing. This in no way excluded
'sentiment' – the addition here of goats in the
foreground – which was always of the essence
of White's or Pennant's response to nature.
Wyndham's description of the landscape
between Machynllyth and Dolgellau shows
the associative turn of his own observations:
'Leaving Machynllyeth, we soon found
ourselves in a truly alpine valley. The rapid
torrent, roaring over a bed of broken rocks,
and, not unfrequently interrupted by
immense fragments, from which it fell in
large cataracts: the woody, and exalted
precipices rising on each side of the river;
and the mountain brooks, which, down the
steep and water-worn gullies, continually
rattled about us, formed a miniature picture
of the romantic scenes, which are found
between Aigues Belles and Mount Cenis'
(2nd ed., p. 104).
 Wyndham's original purpose in publishing
his *Tour* in 1775 had been to encourage

visitors to see in Wales the sublimities of the
Alps or of Salvator Rosa, and Grimm, as a
Swiss artist, was an apt choice as illustrator.
Ironically, the location of this Chasm may
have been misdescribed: I know of no such
place on any of the roads between Machynllyth
and Dolgellau, and the sketch was more
probably taken a day or so later on the tour,
on the road from Dolgellau into Snowdonia.

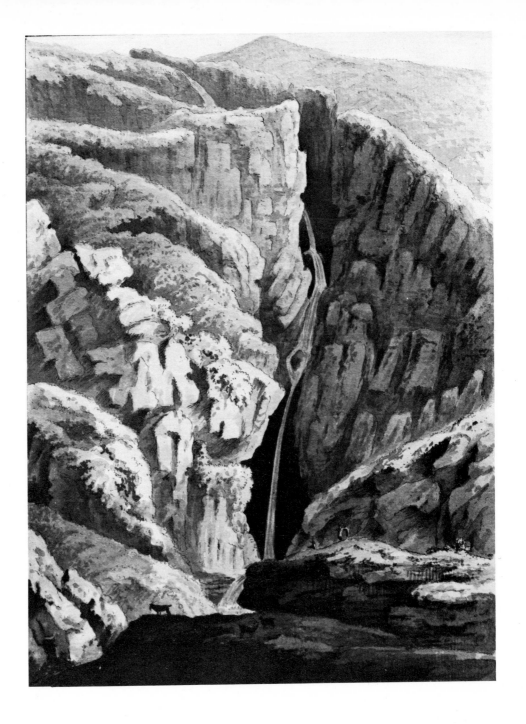

10 Rev William Gilpin
1724–1804
Landscape with River and a Bridge

Reed pen and ink wash on laid, prepared with a pink wash; 26·3 × 36·1 cm.
WG blind stamp, Lugt (*Suppl.*) no. 2622ª, lower left *recto*.
Inscribed in pencil *verso*: *Gilpin.*
PROVENANCE Gilpin Sale, Christie's, 6 May 1802 or 6 June 1804; Rev Chauncy Hare Townshend, by whom bequeathed to the Museum, 1868. 1433-1869
EXHIBITED London, Kenwood, *William Gilpin and the Picturesque*, June–Sept. 1959, no. 95.
LITERATURE C P Barbier, *William Gilpin*, 1963.

The scene here, I think, is an evocation of the Wye – specifically the Wye at Goodrich Castle. The drawing is not an illustration for the *Wye Tour* (though the red wash is imitated in a number of the *Wye Tour* aquatints) but is an illustration of his teaching that the artist should meditate graphically on the objects presented by nature, achieving through his power of selection and combination a picture satisfying to the eye. Goodrich, in fact, as Gilpin first saw it, was highly exceptional as a view in nature: it was 'correctly picturesque', but as his boat sailed on up the river (towards the viewpoint of the present drawing) the retrospects required more artistic intervention. In scenery such as this, topographical accuracy is pictorially impossible and tends to be self-defeating: 'a *portrait* [of a place] characterizes only a *single spot*. The idea must be relinquished, as soon as the place is passed. But such imaginary views as give *a general idea of a country*, spread themselves more diffusely; and are carried, in the reader's imagination, through the *whole description*.'

'. . . he who works *from imagination* – that is, he who culls from nature the most beautiful parts of her productions – a *distance* here; and there a *fore-ground* – combines them artificially; and removing every thing offensive, admits only such parts, as are *congruous*, and *beautiful*; will in all probability, make a much better landscape, than he who takes all as it comes; and without selecting beauties, copies only what he sees presented in each particular scene' (Gilpin's italics; *Lake District Tour*, 1808 ed., pp. xxiv–xxvi).

Gilpin was not, of course, a talented executive draughtsman, nor was he gifted with particular originality in the conception of landscape. But through his example as a tourist and as a literary stylist, and through his boldly simplified answers to aesthetic problems, he was a formative influence on his generation. Like the later Picturesque theorists, he was a popularizer – a brilliant publicist, clear and repetitive in his messages. Largely under his influence the Picturesque was, I think, the first of the (substantially) nineteenth-century movements that were simultaneously the concern of the *avant garde* and of ordinarily cultivated people. Gilpin taught a very large number of people the leading ideas of advanced connoisseurship, and gave to popular culture a vocabulary and discipline of visual experience. Such powers were not widely established in Britain before Gilpin and the Picturesque, but their presence afterwards helps to account for the extraordinary visual richness of British culture through most of the next hundred years.

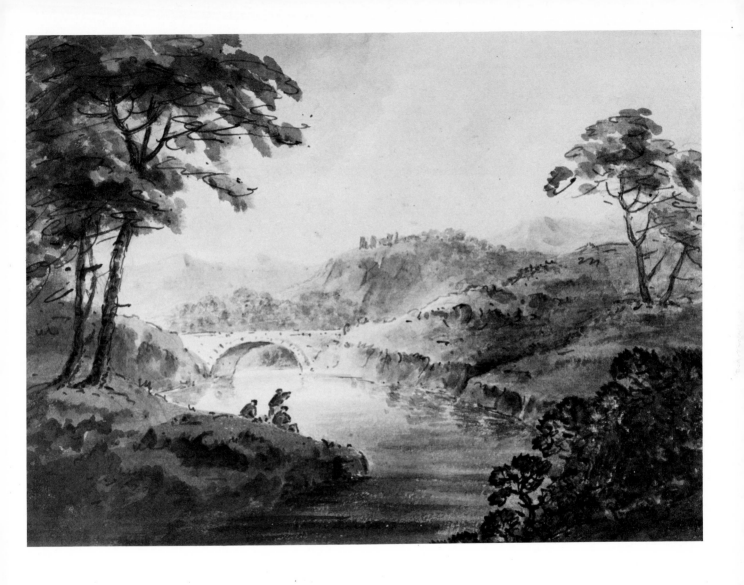

11 Thomas Hearne
1744–1817
The Teme at Downton, Herefordshire

Pen and ink with grey and brown wash on cream laid, put down on thick cream wove; 32·1 × 34·9 cm.
Faded: loss of blue in the sky evident from the upper margin where a mount once protected the surface from light.
PROVENANCE W Smith; by whom bequeathed with the rest of his collection, December 1876. 2933–1876
LITERATURE M Hardie, *Watercolour Painting in Britain*, 1966, I, 174–7, repro fig. 182; see also N Pevsner, 'Richard Payne Knight', *Studies in Art, Architecture and Design*, 1968, I, 109–25.

Downton Castle was the creation of Richard Payne Knight (1750–1824), designed by him at the age of 24, and nominally finished in 1778. It is an astonishing achievement for a young amateur, and, regarded purely as a building, is of the greatest importance in the pre-history of the gothic revival. The real point about Downton, however, was the planned relationship between the house and the site: 'Houses should be irregular where all the accompaniments are irregular', wrote Knight later, and it was in accordance with this maxim that he developed his theory of the Picturesque.

 This theory was first advanced by him in 1794–5, in a verse polemic called *The Landscape*, dedicated to Uvedale Price and illustrated by two extremely apt engravings after Hearne.* Hearne evidently worked a lot for Knight (it is impossible to be precise

* The second engraving shows an 'Elizabethan' house set in a landscape adorned by the natural processes of growth and decay. The bridge is of the pattern used in the present drawing.

about the extent of this, but a set of views is still preserved at Downton) and I think it is not fanciful to suggest that he may have contributed materially to the evolution of picturesque Downton. It would be consistent with everything that Knight said about the improvement of land and the aesthetic classification of views, that he should have used a draughtsman to test his ideas. Knight argued that the Picturesque was purely what was paintable, that it had no objective, separate place in the classification of aesthetic effects. For him to claim that Downton was Picturesque therefore logically entailed the demonstration that, unlike parks by Capability Brown or Humphrey Repton, his work was directly paintable. And Repton generously acknowledged his success:
'It is impossible, by description, to convey an idea of the natural charm [of the Teme Valley] or to do justice to that taste which has displayed these charms to the greatest advantage. A narrow, wild, and natural path sometimes creeps under the beetling rock, close by the margin of a mountain stream. It sometimes ascends to an awful precipice, from whence the foaming waters are heard roaring in the dark abyss below, or seen wildly dashing against its opposite banks; while, in other places, the course of the river being impeded by natural ledges of rock, the vale presents a calm, glassy mirror, that reflects the surrounding foliage. The path, in various places, crosses the river by bridges of the most romantic and contrasted forms; and, branching in various directions, including some miles in length, is occasionally enriched by caves and cells, hovels and covered seats, or other buildings, in perfect harmony with the wild but pleasing horrors of the scene'

(Repton, *Sketches and Hints*, quoted from Pevsner, p. 120).

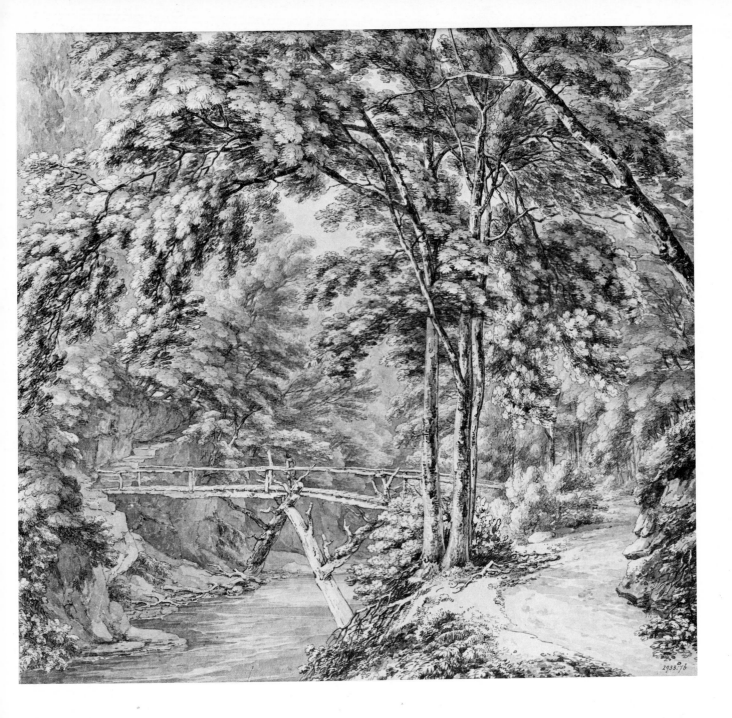

12 Michael 'Angelo' Rooker
1743 or 1746–1801
Godinton, near Ashford, Kent

Watercolour over pencil on cream wove;
35·7 × 25·6 cm.
Faded, the original colour preserved in
marginal strips.
PROVENANCE William Smith, by whom
given to the Museum, 1871. 1727–1871
LITERATURE Luke Herrmann, *British
Landscape Painting of the 18th Century*,
1973, p. 45.

Godinton was built for Captain Nicholas Toke
in the first quarter of the seventeenth century.
The rainwater heads are dated 1628. It is a
good product of the Kentish vernacular
Jacobean style, following in some aspects of
its treatment the example of Knole. Between
1791 and 1837 it was extended and re-modelled
with considerable sympathy in the manner
of the Jacobean Revival, a movement which
began early in Kent, and which was deeply
influenced by the Picturesque. But Rooker's
view, which antedates the alterations, was not
a study of an architectural style, at least not
in any way that could contribute to a scholarly
revivalist movement. It bears rather on the
background of that movement. Proceeding
from the observation of a particular place,
Rooker used the Picturesque to evoke a
sympathetic sense of the past. The mechanism
of this is worth looking at.

Rooker was a draughtsman who travelled
and made careful, accurate drawings of
particular places, which were coveted equally
by connoisseurs and antiquarians for their
aesthetic and their documentary value. His
work was an efficient denial of the thesis that
the pictorially pleasing, or the Picturesque,
was fundamentally different from what was
to be found in Nature. Rooker, and artists
like Hearne, simply ignored this Gilpinesque,

classicizing distinction and insisted in effect
that the Picturesque was necessarily concerned
with actual places because of its basic concern
with the processes of organic growth and
decay in creative combination with the works
of men. In this they received powerful
theoretical support from the aestheticians of
the Hereford School, especially from Price,
whose version of the Picturesque came from
a careful study of the world he found around
himself. In his work, the Picturesque took on
a historical significance as the visual evidence
in physical objects of passing and long past
time. The 'broken tints' of rock or masonry,
the 'partial concealment' by the growth of
vegetation, the 'brown trees' and mellow
tones of the autumnal landscape, were not
only pleasing to the eye: they were signs of
time and transience, capable of activating the
historical imagination. Rooker and his peers
used this vocabulary of signs in their treatment
of old buildings, emphasizing the continuum
of history in particular places, and developing
the idea that the best buildings and the best
way of living expressed an organic relationship
between past and present. At Godinton, as
we have seen, such Picturesque ideas found
their issue in architectural revivalism.

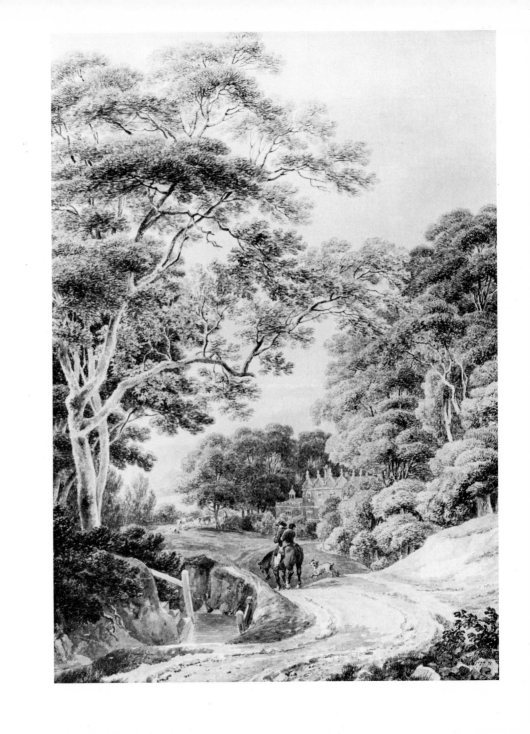

13 Thomas Rowlandson
1756–1827
Dr Syntax sketching after Nature

Watercolour, pen and ink, over pencil under-drawing, on white wove; the design traced through in pencil *verso* and the outlines impressed for transfer; 14 × 21·1 cm. Inscribed in pencil, lower margin, *recto*: *He remarks on what Animals are Picturesque.*
PROVENANCE Rev Alexander Dyce, by whom bequeathed to the Museum, 1869. D.803
LITERATURE R Paulson, *Rowlandson, A new interpretation*, 1972, p. 88.

The drawing was made for plate 19 of *The Tour of Dr Syntax, in Search of the Picturesque*, contributed by Rowlandson to Ackermann for his monthly *Poetical Magazine* from 1809, and first published, as a single volume in heroic couplets, in 1812. The letterpress, produced after the drawings, was by William Combe:

The Doctor now, with genius big,
First drew a cow, and next a pig:
A sheep now on the paper passes,
And then he sketched a group of asses
Nor did he fail to do his duty
In giving Grizzle all her beauty.
'And now,' says Miss (a laughing elf)
'I wish, Sir, you would draw yourself'
'With all my heart,' the Doctor said
'But not with horns upon my head.'
'– And then I hope you'll draw my face.'
'In vain, fair maid, my art would trace
Those winning smiles, that naïve grace.
The beams of beauty I disclaim;
The picturesque's my only aim:
My pencil's skill is mostly shown
In drawing faces like my own,
Where time, alas, and anxious care
Have placed so many wrinkles there.'

The poem is not one of the subtler, nor one of the funniest contemporary satires on the Picturesque. Dr Syntax is a simple soul by comparison with the inventions of Jane Austen and Thomas Love Peacock, but he was a great success. He was based on Gilpin, who had been a schoolmaster before becoming Rector of Boldre in the New Forest, and he emerges as a sort of Parson Adams – a figure of total innocence whose vulnerability to satire comes from naïveté and silliness rather than from pretension or guile. Between them Combe and Rowlandson knew a lot about the Picturesque, and they hit off most of the foibles and preciosities of the connoisseur. The present drawing refers to the picturesque preference for shaggy and ill-formed animals over greyhounds and racehorses. The latter were (according to Burke) definitively beautiful, but the advanced picturesque connoisseur was more interested in the visual qualities of the pig or spavined mule. The extension of this argument to cover buildings and human beings led to much sceptical mirth (Uvedale Price's logical step to the absurd was to argue for the attractions of a woman's squint), and of course Syntax, *in corpore suo*, is himself an example of the picturesque.

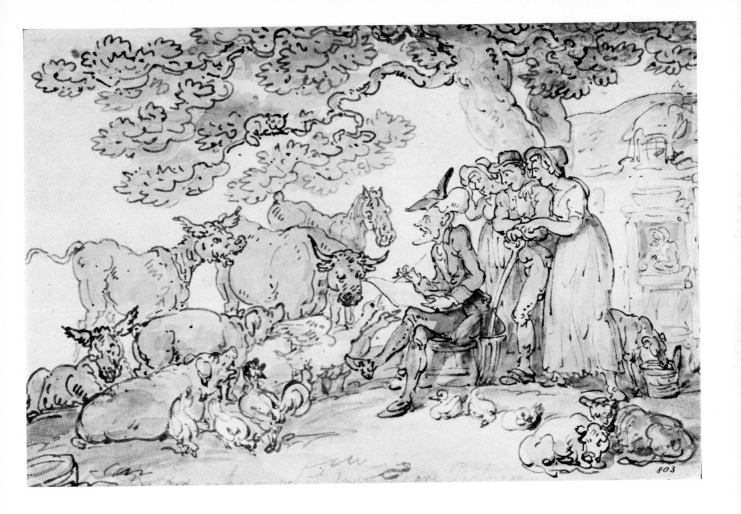

803

14 John Alexander Gresse
1741–1794
Bridge, Llangollen

Pen and ink and watercolour, with some pencil, on white wove; 38 × 53·7 cm.
The paper stained possibly by the artist, but browned and engrimed especially in the margins by exposure.
Inscribed in pencil, lower right: *Bridge Langollen*; and *verso*, by the same hand: *Bridge of Langollen/by Gresse.*
PROVENANCE William Smith, by whom presented to the Museum, 1871. 1731–1871
LITERATURE I Williams, 1952, p. 47, pl. XXXV; M Hardie, 1966, p. 164, pl. 162.

Gresse was an artist of Swiss parentage, but born and brought up in England. Although from 1755 he enjoyed a considerable reputation as a draughtsman and teacher, his work has almost entirely disappeared (or been subsumed into the *oeuvre* of other artists). The attribution of the *Llangollen Bridge* rests entirely on the inscription, and (apart from the smaller drawing in the British Museum) there is no sufficient body of work certainly by him from which any idea of his development or major interests can be reconstructed. *Llangollen Bridge* stands virtually alone, but as a monument it is by no means without clues to its origin.

The paper, a hand-made wove, suggests a date after about 1780. Paper of this kind was introduced into England in the 1750s by John Baskerville, but it is rarely met with in drawings before the last couple of decades of the century, and after 1790 becomes increasingly common. I would regard *Llangollen*, therefore, as likely to date from the last years of Gresse's life. This would be consistent with what we know of the history of tourism. It would be exceptional if Gresse had travelled and made drawings in North

Wales before about 1775: after that date increasingly likely, and the probability must be that he was at Llangollen in the late eighties or early nineties. Again, the visual qualities of the drawing, the choice of subject, the treatment of trees and bushes, the 'broken tints' of the colouring, conform with the Picturesque values advocated by Uvedale Price (1794), and relate directly to views by John Webber (another Swiss draughtsman) in Wales around 1790.

Gresse was the master of Robert Hills, who emerged as an independent professional around 1790. There are drawings by Hills,* made in the Lake District and in the Southern Home Counties, which are markedly similar to Gresse's work. These drawings date, I think, from the early years of the nineteenth century, and are similar to work done by artists such as Cornelius Varley, Joshua Cristall and Robert Kerr Porter. A version of Girtin's *Cayne Waterfall, near Dolgellau* (c. 1799) in the British Museum, also conforms to this type, the features of which are a strong graphic linear base, bright fragmentary local colour, and a large empty foreground. Such drawings are often called 'unfinished', and certainly they are not public exhibition pieces; in the context of early romantic art, they are correctly called sketches. That is to say they do not necessarily lead on to finished work,† but are intended as an alternative and even more efficient means of stimulating imaginative response. Optically they are extremely convincing. They record the way the eye

focuses on the middle and far distance in patches or panorama, and registers the brighter spots of colour. The sketch in theory, focusing on what the eye actually notices, distinguishes the essential and avoids the dissipation of imaginative power in the laboured detail of surroundings.

* In Birmingham, J R Holliday collection.
† Girtin's *Cayne Waterfall* in fact does, but it was copied in sketch form by James Ward, a friend of Robert Hills.

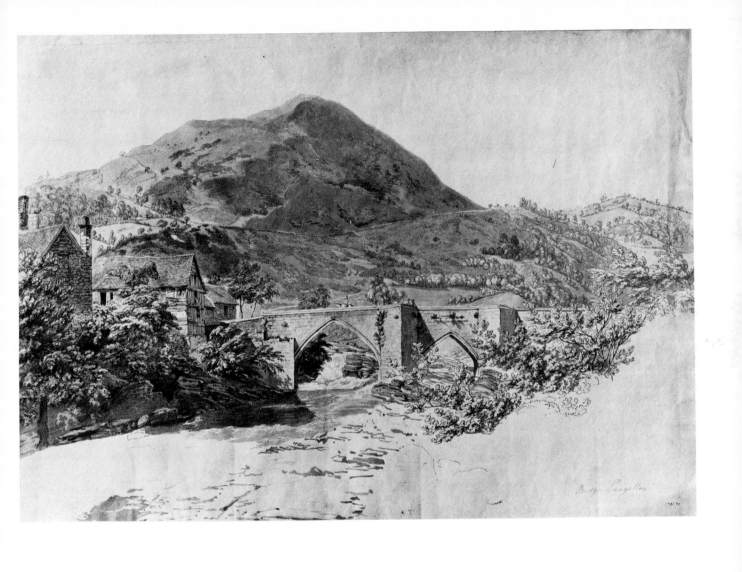

Bridge Llangollen

15 Alexander Cozens
1717?–1786
Idea for a landscape

Indian ink on white wove, w/m *JW*
and with heavy regular lines (like wire marks)
across the sheet; 18·3 × 23·7 cm.
PROVENANCE Walker's Galleries, from whom
purchased, 1920. E.4276–1920

It may not be strictly accurate to call this
drawing a 'blot': the aquatint illustrations to
Cozens' *New Method of Assisting the
Invention in Drawing Original Compositions
of Landscape* indicate that a properly suggestive
'blot' would be bolder, looser, less precisely
legible than the present piece.
'A true blot is an assemblage of dark shapes
or masses made with ink upon a piece of
paper, and likewise of light ones produced
by the paper being left blank. All the shapes
are rude and unmeaning, as they are formed
with the swiftest hand. But at the same time
there appears a general disposition of the
masses, producing one comprehensive form,
which may be conceived and purposely
intended before the blot is begun. This
general form will exhibit some kind of subject,
and this is all that should be done designedly'
(A P Oppé, *Alexander and John Robert Cozens,
with a reprint of Alexander Cozens' 'A New
Method of assisting the invention of drawing
original Compositions of Landscape'*, 1952,
p. 169).
Blot or not, however, there can be no doubt
that this is one of Cozens' inventions, and as
such it is unmistakably the work of a
powerful, original mind, and a brilliant
executive talent.
 The *New Method* was Cozens' last work,
and it failed. His reputation had never been
entirely secure and he had never done enough
as a painter to gain admission even as an
Associate of the Royal Academy. He was
mainly a teacher and thinker, but like most
artists he lacked the educated verbal articulacy
which eases understanding. It is difficult now
to be sure what Cozens thought; neither his
published nor his unpublished works are
complete, and it is possible only to make some
tentative guesses. I think Cozens realized that
fundamentally an artist worked by inventing
signs, and that the relation between an object
and its sign gave a valuable insight into the
immemorial problem of the relation between
matter and spirit. Cozens' own phrases, the
'general principles of nature, founded in
unity of character, which is true simplicity'
echo the language of Renaissance science and
philosophy, and refer ultimately to the
cabalistic search for a law to explain all
phenomena. I think that Cozens thought
that art – the repertory of graphic signs,
combining through the laws of composition
into the ideal of nature – was, like the calculus,
a means of penetrating the fundamental
arcana of existence.
 But Cozens was not a hopeless, lonely
eccentric pursuing his studies in isolation
from his empirical English contemporaries.
Seen, as Beckford was the first to perceive him,
as a system builder, Cozens was one among
many. The age of Linnaeus was immensely
prolific in the publication of attempts to
establish systems of Phenomena, and it is
rarely easy to distinguish the enlightened,
'scientific' from the obscurantist and mystical.
The entire Picturesque movement, itself
founded on Burke's taxonomy of aesthetic
sensation, was a prescription for ordering
and understanding the appearances of nature.
In the richness of this intellectual context,
and with his *Principles of Beauty relative to
the Human Head* (1778) in competition with
the physiognomy of Lavater, Cozens'
contribution was fragmentary, incoherent, and
soon largely forgotten. But his contemporary
reputation, and presumably the presence of a
copy of the *New Method* in Sir George
Beaumont's library, had one appropriate
consequence: it gave Constable the
opportunity to copy in pencil the plates that
Cozens intended originally for another of his
definitive classifications, the *Skies*.

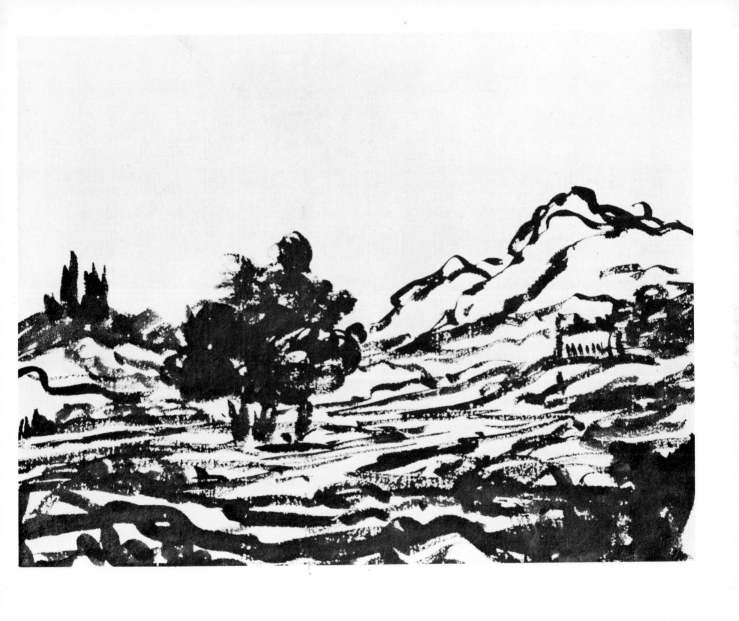

16 J R Cozens

1752–1797

View from Mirabella, the Villa of Count Algarotti on the Euganean Hills

Watercolour over slight pencil underdrawing, on white wove; 25 × 37·5 cm.
PROVENANCE William Beckford; his sale, Christie's, 10 April 1805, lot 36 bought anonymously (£2.15.0); John Edward Taylor, by whom presented to the Museum 1894. 120–1894
EXHIBITED *Watercolours by John Robert Cozens*, Manchester (Whitworth Art Gallery) and London (VAM), 1971, no. 49.
LITERATURE C F Bell and T Girtin, 'The Drawings and Sketches of John Robert Cozens . . .', *Walpole Society*, XXIII, 1934–5, p. 53, no. 216, repro pl. XVIII; A P Oppé, *Alexander and John Robert Cozens*, 1952, pp. 147, 148; repro. pl. 38.

William Beckford took Cozens with him on his third tour to Italy. It was Cozens' second trip (the first, 1776–9, had resulted in a series of sketches made under the 'inspection' of Payne Knight), and the party left Dover in May 1782, travelling rapidly down through Germany and Switzerland and coming into Italy in early June. The trip on the 19th from Padua to the Algarotti villa in the Euganean Hills could have been something of a pilgrimage for Beckford: Francesco Algarotti (1712–64), philosopher, scientist, art historian and man of letters, was one of those eighteenth-century men who made a fair attempt at mastery of all fields of human knowledge, and in whose footsteps Beckford at nineteen seemed capable of following. Beckford in fact was finishing *Vathek* at this time and had but recently withdrawn from an extraordinarily hectic London Season. He was in love, and he was fascinated by the volatility and piquancy of his own moods. This was the material that he drew upon for

his writing and his music, and it seems probable that, as part of the cultivated synaesthesia of the Beckford circle, Cozens set out to embody such moods in his visual art. There are striking parallels between passages of Beckford's letters and journals and the drawings that Cozens later made to fulfil Beckford's commission. At Mirabella their thoughts were of Tasso, and Armida's enchanted garden of indolence:

'After dinner we drank Coffee under some branching Lemons which spring from a Terrace commanding a boundless Scene of Towers and Villas – tall Cypress and shrubby hillocs rising like Islands out of a Sea of Corn and Vine. Evening drawing on and the breeze blowing cool from the distant Adriatic, I reclin'd on a slope and turned my eyes anxiously towards Venice, then on some little field where they were making Hay hemmed in by Chestnuts in blossom, and then to a Mountain crowned by a circular grove of Fir and Cypress. In the centre of these shades some Monks have a comfortable nest, a perennial Spring . . . and a thousand luxuries besides, I dare say, which the poor Mortals below never dream of' (to Lady Hamilton, 19 June 1782; Lewis Melville, *Life and Letters of William Beckford*, 1910, pp. 155–6).

It was Cozens' capacity to absorb and re-embody in this idiom the ecstasy and melancholy of his generation that made him such a protean artist of romanticism. In a narrow sense of influence, Cozens leads on through the Monro School and the Beckford Sale of 1805 to the achievements of Girtin, Turner and Constable. In the wider sense, however, the connections come from the European movement of *Sturm und Drang* and

are with the emerging type of Childe Harold – the desolate and alienated individual, from rich northern Europe, who views the ruined civilization of the Mediterranean as the saddest image of his personal Fall.

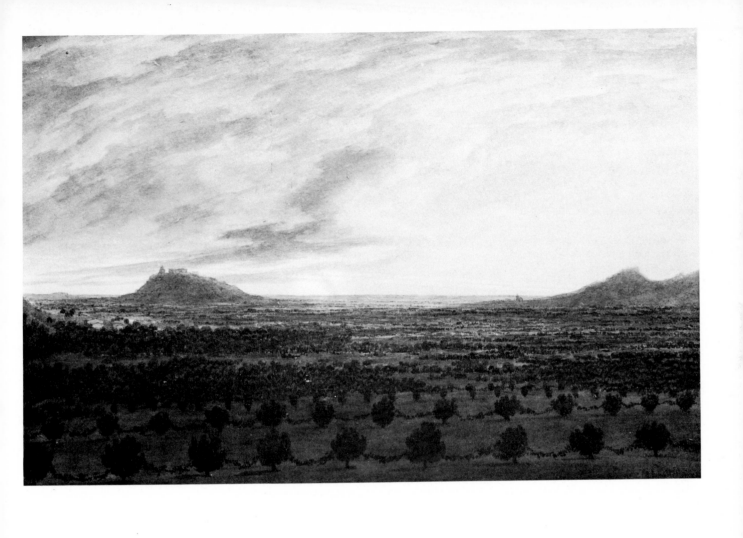

17 Francis Towne
1740–1816
The Source of the Arveiron

Watercolour over pen and ink; the outlines and passages of highlighting deeply incised and rubbed; on four sheets of white laid (each 21·2 × 15·5 cm maximum) on a ruled and washed mount of white laid (w/m J Whatman); 42 × 31 cm (overall). Signed in ink l.r. recto: *F. Towne. delt | 1781 | No 53*, and inscribed on the drawing: *glaciere, rock*; and verso: *No 53 | Light from the right hand | The Source of the Arviron with part of Mount Blanc | drawn by Francis Towne Septr. 17th. 1781.*
PROVENANCE The history is obscured by Oppé's reticence, but his note on p. 116 of the *Walpole Society* article strongly implies that the coloured, mounted Swiss drawings belonged to him rather than the Misses Merivale. In that case, he acquired them from an undisclosed source before 1911, still had them by 1919–20, and disposed of the present drawing to Agnew's in 1920 when it was bought by the Museum. P.20-1921
EXHIBITED 20 Lower Brook Street, Spring 1805 (Towne's one-man exhibition), no. 104 or 107.
LITERATURE A P Oppé, 'Francis Towne Landscape Painter', *Walpole Society*, VIII, 1919–20, pp. 116n., 119 and pl. LXIV.

There are two treatments of this subject by Towne. The other, which is smaller (31 × 22 cm), is in the Oppé collection in London, and is at least as famous as the present example. The view is the source of the Arveiron, a short tributary of the Arve which rises in a 'cavern' at the base of the Mer de Glace. Towne's reference to Mont Blanc may, however, be rather misleading: the peak which dominates the background of the drawing should be one of the Aiguilles, the subsidiary peaks in the range which buttress the main massif of Mont Blanc along the Chamounix valley. These are some of the most astonishing mountains in the world – thirteen thousand foot granite pinnacles rising almost vertically above the valley and glacier – but Towne's reaction was to emphasize neither their Sublimity nor the sentiment, the 'religion and poetry' that travellers after Thomas Gray (1739) had found in the Alps. His concern seems to have been with himself in the act of drawing, and with the work of art as a meditation on the qualities of line and colour, pattern and significance, inherent in the subject.

Technically, the drawing is achieved by means that lay beyond the practice of most contemporary draughtsmen; it demonstrates manipulative expertise in the aggressive cutting and rubbing of the paper on the outlines, the laying and mixing of blue and green washes and the firm over-drawing in pen to make emphases. It is on four pieces of the small thin paper Towne had carried with him through Switzerland from Italy; the basic drawing was done on the spot and the artist's written notes are prominently visible under the colours; on the back are more notes of the precise date, location and conditions of light. The object thus transmits a sense of great immediacy, an extraordinary first-hand connection with the creativity of the artist, with the place which he painted and where he worked. It is an early example of the sketch being exhibited to the world as a specially valuable work of art, more truly a projection of the artist's genius and insight than his later more detailed work in the studio. Such theories were current among advanced neo-classical painters in Rome (from where Towne was returning) and it is with the most austere of neo-classical figure draughtsmen that Towne's landscape style finds its closest analogies. As Professor Rosenblum has remarked – 'the years around 1800 . . . witnessed a dissolution of post medieval perspective traditions as radical as anything instigated by Impressionist colour patches or by that later equivalent of the Greek vase-painting, the Japanese print' (quoted from *The Age of Neo-Classicism*, 1972, p. xxv). The remark helps to explain how Towne's extreme, spare, linear style, the product of neo-classical revolutionism, appealed so directly to the generation of Oppé and Binyon, a generation which had been brought up in admiration of Chinese painting and the Japanese colour print.

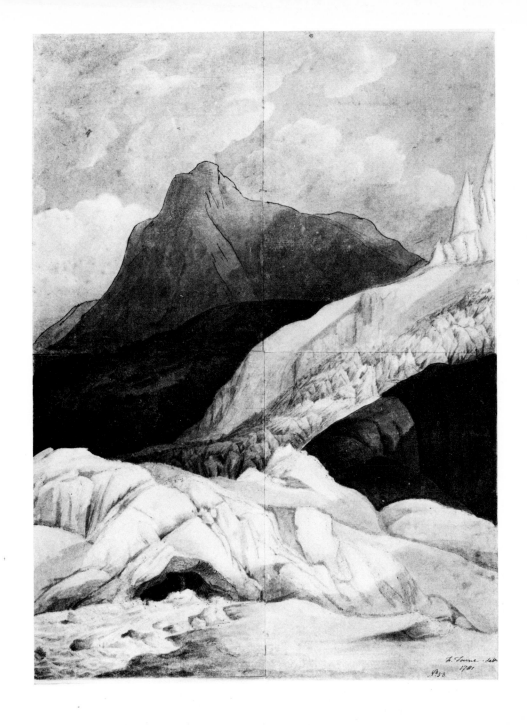

18 William Pars
1742–1782
An Italian Villa

Watercolour over pencil, with some final penwork; on white laid; 22·6 × 32·1 cm. Stamped lower left *recto* and *verso* with the mark of Dr John Percy.
PROVENANCE Dr John Percy; his sale, Christie's, 22 April 1890, lot 929, bt Vokins on behalf of the Museum. 180–1890
LITERATURE M Hardie, *Watercolour Painting in Britain*, I, 1966, p. 88, repro. pl. 64.

Pars' career was broken by his early death in Rome towards the end of 1782, but his output and reputation with the connoisseurs had been considerable, and he had shown himself as one of the most adaptable artists of his generation. He was mainly patronized by the Society of Dilletanti, who had employed him earlier in Asia Minor to make accurate architectural drawings for publication. In 1774–5 the Society granted him funds to continue his training as a painter in Rome and he joined the vigorous community of English artists resident and studying in the city. The group at the English Coffee House was described by Thomas Jones on Wednesday, 27 November 1776 as including: 'Pars, Humphry . . . Jeffreys, J. More & Cousins . . . Banks the Sculptor . . . Tresham, Fuzeli', et al. Jones and Pars were old friends, and Jones' diary provides an invaluable insight into the society of expatriate English artists, especially those most interested in landscape. The arrival of Beckford and Cozens in July 1782 is noticed, and there are valuable anecdotes about Towne's reaction to the Salvatoresque character of Neapolitan scenery ('Memoirs', June 1781, *Walpole Society* XXXII, 1946–8, pp. 103–5).

Towne seems to have been the strongest influence on Pars at the end of his life. Martin Hardie thought that the present drawing represented the source of Towne's colouring in his early Roman views, and Pars may well have influenced the way Towne worked up finished watercolours for commissions. But in his best work the influence was surely the other way. The series of Neapolitan subjects by Pars that were in J Leslie Wright's collection – great finished works that in several instances are virtually identical to treatments by Towne – are a convincing demonstration of the effect that Towne's beautiful classicizing draughtsmanship had on an artist with Italian experience who had the talent to respond adequately to it.

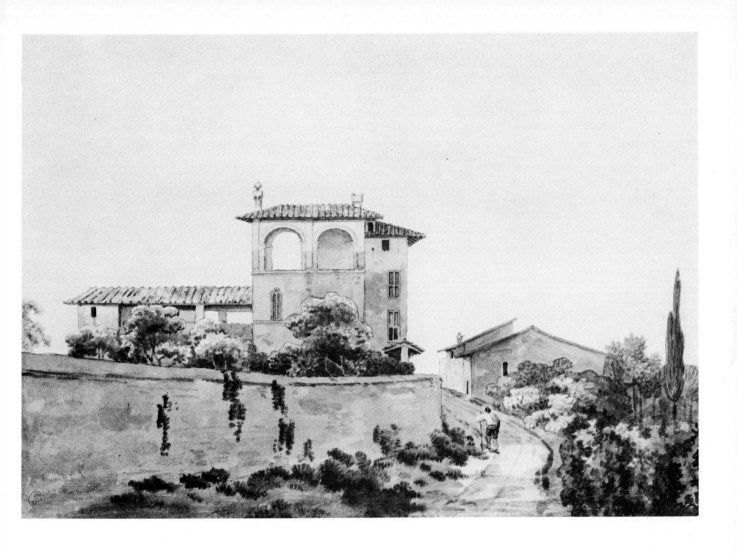

19 J White Abbott
1763–1851
The Langdale Pikes from Low Wood

Watercolour over pen and ink, on white wove
put down on a ruled and washed mount;
24·1 × 18·9 cm.
Signed and inscribed in ink, *verso*: *N⁰ 60/
The Langdale Pikes from Low-wood./J W A*
[interlaced] *July 12. 1791.*
PROVENANCE By descent to the artist's
grand-daughter, Mrs Fanny Jane Elizabeth
Douglas, by whom given to the Museum,
May 1924. P.23–1924

The English Lake District was already
important a whole generation before
Wordsworth, Coleridge and Southey were
dubbed by journalists 'The Lake Poets'. In
1778 the *Monthly Magazine* had commented
'To *make the Tour* of the Lakes, to speak in
fashionable terms, is the *ton* of the present
hour.' This was partly the effect of example
(especially that of Gray, whose *Journal of a
Tour to the Lakes* was published in 1775),
and partly the effect of a widening conviction
that the full repertory of European landscape
was available to the observant traveller within
Britain. White Abbott in fact, though a
gentleman in a small way, never went abroad,
and made only the one tour to Scotland and
the Lakes in 1791.

His work in the Lakes was virtually the
equivalent of Towne's, and probably shows
the folly of believing that the Englishman's
aesthetic universe could be complete without
the Alps. But what both Towne and Abbott
did manage in the Lake District was
particularity. Abbott's Langdale Pikes are
instantly recognizable, his viewpoint on the
road in front of the old inn at Low Wood by
Windermere is firmly located and habitable.
The treatment may be unsophisticated and is
certainly conventional – the Gilpinesque

'sidescreens', the water 'leading the
perspective', the blue of the distant
mountains – but there is no conflict between
this formal discipline of Picturesque
composition and the expression of an
authentically romantic precision about the
place.

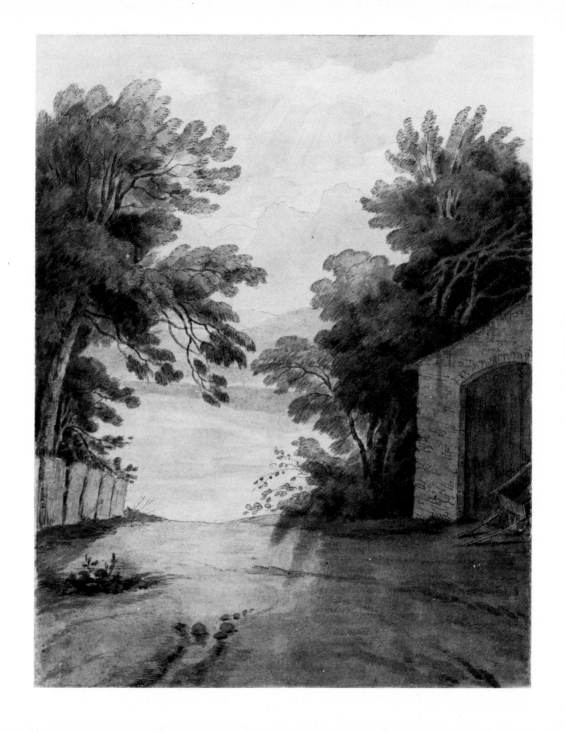

20 Thomas Girtin
1775–1802
Kirkstall Abbey, Yorkshire: Evening

Watercolour with added penwork over pencil underdrawing; on white laid put down on card; 31·8 × 52 cm.
A deep scratch centre right, and the lower right corner re-attached. A *pentimento* lower centre, where three cows and a figure(?) have been removed.
PROVENANCE W J Shard, from whom purchased, November 1885. 405-1885
EXHIBITED Manchester, Whitworth Art Gallery, and VAM, 1975, no. 79 (the catalogue contains full exhibition history, bibliography and a longer provenance).
LITERATURE T Girtin and D Loshak, *Art of Thomas Girtin*, 1954, no. 414 (repro.).

Practically the whole of Girtin's output consists of drawings of particular places. There are few subjects that present any difficulty over identification: his buildings are carefully and accurately drawn, and his rivers, waterfalls and mountain landscapes have usually yielded to topographical investigation. As a pupil of Edward Dayes and employee of James Moore (the publisher of *Monastic Remains and Ancient Castles in England and Wales*), Girtin was a well-trained architectural draughtsman closely in touch in his earliest years of professional activity with antiquarianism and historical study. These interests remained in his later work, both in his comprehension of buildings as solid, three-dimensional presences, and in the attention he gave to the texture of ruined or weathered stone. His emphatic treatment of the latter is recognizably Picturesque, and like other draughtsmen of the 1790s and early 1800s, he used Picturesque qualities as a way of portraying the passage of time.

By themselves, however, these accomplishments were not sufficient to attract the sort of attention that Girtin had gained by his mid-twenties. In February 1799 Farington recorded that he was being spoken of as a 'genius' – a word that was not usually applied in Academy circles or among the connoisseurs to topographical and antiquarian draughtsmen. What contemporaries noticed was an extraordinary power of imagination, focused on human emotions, which expressed itself with precocious austerity.

In *Kirkstall Abbey*, for example, Girtin addressed himself to the familiar theme of the ruined abbey at sunset, but made no attempt to heighten melancholy by the introduction of emblems. The effort seems to be directed entirely towards simplification and lowering of tones. The composition is formed on a plan of shallow triangles in orderly recession, culminating in the narrow gleam of light from the setting sun; the latter is the brightest accent in the picture, and the colour otherwise is limited to crepuscular browns and greys. The result is an intensification of melancholy, an uncompromising recognition of mortality in the denial of brightness and vivid complexity. Since the drawings that Cozens made for Beckford in Italy, there had been no English artist capable of confronting the joyless isolation of melancholy with such bleak honesty.

Girtin must have seen Cozens' work in Sir George Beaumont's collection, and he is known to have copied from the Swiss sketches at the house of Dr Monro. Cozens had spent the last years of his life as one of Monro's mental patients, and in the light of Girtin's subsequent early death, it is tempting to see in the Monro circle signs of a romantic identification of ill-health and genius. Dayes may have had some such idea in mind when he described Girtin's death as a warning to 'young persons against the fatal effects of suffering their passions to overpower their reason'. Though he thought Girtin's drawings were too slight, he allowed that they 'must ever be admired as the offspring of a strong imagination' (quoted from Girtin and Loshak, p. 218). A strong imagination, the essential quality of genius, could be both a function and a cause of ill-health, and the idea of the genius who must die young involved a prophecy that was often actually fulfilled in the nineteenth century.

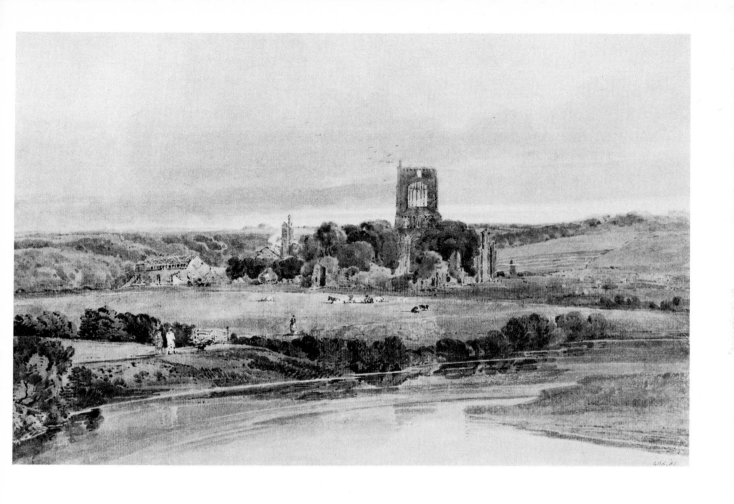

21 John Sell Cotman
1782–1842
Chirk Aqueduct

Pencil and watercolour on pale brown laid (flecked with impurities); 31·6 × 23·2 cm.
PROVENANCE Fine Art Society, from whom purchased, February 1892. 115-1892
LITERATURE S D Kitson, *Life of John Sell Cotman*, 1938, p. 44, pl. XI; F Klingender, *Art and the Industrial Revolution*, 1947, p. 85.

Chirk Aqueduct is thought to be a development of a pencil sketch made on the spot during Cotman's second Welsh tour of 1802. On grounds of style, the watercolour is dated by common consent to the winter of 1803–4, and connected thus with the famous Greta series of drawings, done in the neighbourhood of J B S Morritt's picturesque estate of Rokeby in Yorkshire in 1804–5. In subject, however, it belongs with the industrial revolutionary drawings of 1800–3, and marks in effect a turning point in Cotman's early development.

 In the first years of the century, the strongest influence on Cotman was certainly Thomas Girtin. Cotman would have known Girtin's work from the exhibitions, and from seeing it at the houses of collectors like Dr Monro and probably Sir George Beaumont. Possibly, as Kitson suggests (p. 21), they met and worked together at Conway in 1800, and such a contact would have been reinforced by Cotman's first appearance in 1801 among Girtin's 'Brothers'. This group of young artists was the first of the Sketching Societies, and it met to study the expression of images derived from poetry in rapidly executed monochrome sketches (Jean Hamilton, *The Sketching Society*, VAM, 1971, pp. 6–7). In response, Cotman's style became powerfully dramatic: his palette became darker in colour, more concentrated in range, and he organized his compositions around a central area of preternatural brightness. The two masterpieces of these years, the *St Mary Redcliffe Bristol* (1801; British Museum) and the *Bedlam Furnace* (1802; Hickman Bacon), show how the style applied to architectural antiquities and to the industrialized landscapes of the Severn Valley. Coalbrookdale especially became an image of the Inferno, or of the Miltonic Hell, wrapped in dark fires and oppressive exhalations. The poetic correspondences were of the kind explored in the Sketching Society and systematized in Burke's definition of the Sublime.

 Chirk Aqueduct, however, is rather different. In terms of the Sublime it relies not on direct allusion to poetry but on the suggestive portrayal of great size – the implied infinity of the incomplete series of arches, the overbearing height of the structure emphasized by the low viewpoint, and the dizzy sensation of a simultaneous upward and downward view. Compositionally there may be an unspecific debt to Piranesi, whose complete etchings Cotman was trying to buy a few years later when he wrote 'I decidedly *follow* Piranesi, however far I may be behind him in every requisite' (Feb. 1811, quoted from Kitson, p. 145). In execution, also, *Chirk Aqueduct* marks a development. Though the pencilling is still recognizably influenced by Girtin, the sense of texture is quite different: there is a planned lack of textural emphasis over great areas of the architecture (the structure was new, after all, with none of the irregularities and dilapidation of ages) and the sky is a flat cloudless blue. There are no figures, no adventitious aids to imagination: poetic allusion is absolutely excluded. As Burke argued it could, the imagination responds directly to the physical properties of the scene it contemplates. And the scene is actually a modern artificial waterway over a natural valley. It is associated with nothing from the past or from the poets, and its sublimity is a matter only of its size and massive presence. The sense of wonder that is the effect of Sublimity is directed here not towards dread and terror as in the Coalbrookdale drawings, but to the celebration of human power, calm and rational, in cool washes and spare lines.

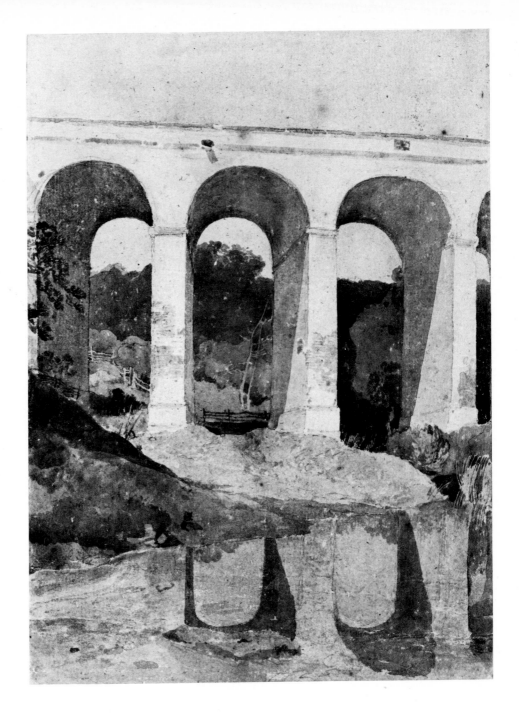

22 John Crome
1768–1821
Wood Scene c. 1810

Watercolour on laid, possibly stained by the artist pale brown; 57·3 × 41·8 cm.
Faded; marginal strips give some indication of former colour.
PROVENANCE William Smith, by whom presented to the Museum, 1871. 1749–1871
LITERATURE D & T Clifford, *John Crome*, 1968, no. D58 (pl. 48); this includes a full bibliography and exhibition history.
EXHIBITED *John Crome*, Norwich Castle Museum and Tate Gallery, 1968, no. 77.

Wood Scene epitomizes Crome's relation to the Picturesque. As an image it is a close and contemporary analogue of the wooded lanes described by Uvedale Price in the *Dialogue on the Distinct Characters of the Picturesque and the Beautiful*, and in the *Essay*:
'. . . in hollow lanes and bye roads, all the leading features, and a thousand circumstances of detail, promote the natural intricacy of the ground: the turns are sudden and unprepared; the banks sometimes broken and abrupt; sometimes smooth, and gently, but not uniformly sloping; now wildly over-hung with thickets of trees and bushes; now loosely skirted with wood . . . and the border of the road itself, shaped by the mere tread of passengers and animals, is as unconstrained as the footsteps that formed it. Even the tracks of the wheels (for no circumstance is indifferent) contribute to the picturesque effect of the whole: the varied lines they describe just mark the way among trees and bushes . . .
These are a few of the picturesque accidents, which in lanes and bye roads attract the notice of painters. In many scenes of that kind, the varieties of form, of colour, and of light and shade, which present themselves

at every step, are numberless; and it is a singular circumstance that some of the most striking among them should be owing to the indiscriminate hacking of the peasant, nay, to the very decay that is occasioned by it' (*Essay on the Picturesque as compared with the Sublime and the Beautiful*, 1794–8, ed. 1810, I, pp. 24–6).
As far as we know Crome had no knowledge of any theoretical work on aesthetic problems, and he was not one of the artists cited by Price as exemplifying the Picturesque in pictorial practice. The similarity between them was probably due to their common interest in seventeenth-century Dutch and Flemish art, and to the fact that the Picturesque, more than any other aesthetic movement, was deeply founded in popular taste. What was important about Price was not the precise bearing of his controversialism, but the way that he articulated judgements that were widely shared and certainly evident in Crome's pictures. The point about the lane was that the artist accepted it as he found it, not as a place rich in association, nor as the raw material of his ideal. After about 1790 the tendency of the Picturesque was increasingly towards a form of 'naturalism' that placed the highest aesthetic value on appearances and effects which had nothing to do with art, and were connected with men only in so far as they were the results of 'natural' man exploiting the land for survival. Much East Anglian art – much of Crome's art – was concerned precisely with this union of man and nature at the level of non-heroic humdrum daily life, in the inns, windmills, villages, canals, boats, beaches, old fences and cart roads of the inhabited country. The basic insight is of man as a part of nature,

contributing from inside to a created whole which is the only proper object of aesthetic approval. In Crome, I think, the insight goes no further than this, but later in the century Picturesque interest in the peasantry as a subject for art led on to the development of a distinctive English theory of realism in art and literature.

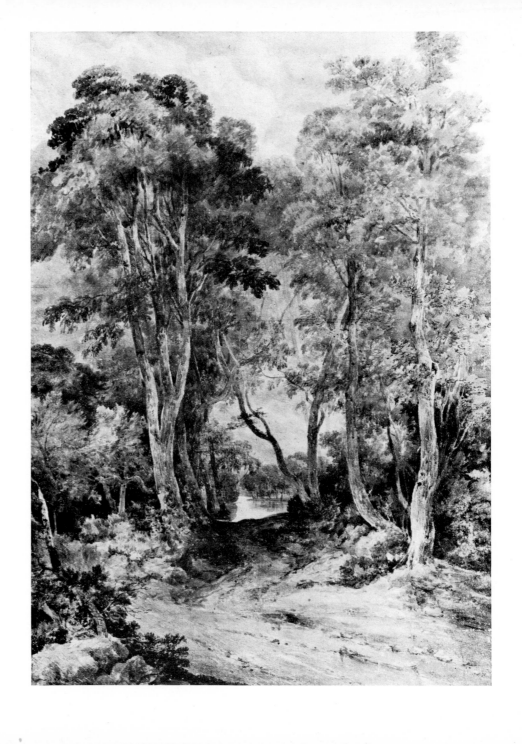

23 Robert Blemmell Schnebbelie
d. 1849
Outside the Theatre Royal, Drury Lane

Watercolour over pencil on white laid
(w/m *JRU . . . 1819*). A marginal strip to
right shows the remains of former colour.
Signed with the brush, lower right: *Robert
Blemmell Schnebbelie, 1821*; and inscribed
lower left: *Original 18th June, Evening*;
verso in erased pencil: *Drury Lane Theatre
the evening of the 18th June 1821 and on the
following Monday 25th June/1821 an
Entertainment of Theatricals Masquerade and
Ball [Sc?] in Honour of the Memorable/Battle
of Waterloo and in [Commemoration?] of the
approaching Coronation of his Majesty/
George the Fourth.*
PROVENANCE Hogarth and Sons; from whom
purchased March 1877. 638-1877
LITERATURE Martin Hardie, *Watercolour
Painting in Britain*, III, 1968, p. 14.

The 'new' Theatre Royal was rebuilt after the
fire of 1809 to designs by Benjamin Wyatt
with funds controlled by the radical Whig
Samuel Whitbread. The programme on
18 June under the 'immediate patronage and
sanction' of the King consisted of a
performance by Elliston and his 'Corps
Dramatique', followed by an 'Operatic'
entertainment, 'Magic and Recreative
Philosophy' by a M. Chalons, and a display
of strength, balance and statuesque poses by
M. Esbrayat 'Model of the Royal Academy'.
This was to finish at 11 o'clock, being
followed by the masked ball and supper in
the auditorium and boxes, which were to be
decorated by ten thousand square feet of
'Panoramic, Rural and Marine' paintings,
together with thousands of 'variegated Lamps'
and 'Festoons of Artificial Flowers'. The
nobility and gentry paid £1.5s each.
Schnebbelie's drawing shows their arrival.

Schnebbelie was the grandson of a Dutch
immigrant confectioner; his father, Jacob
Schnebbelie (b. 1760), was a successful
draughtsman patronized by the Society of
Antiquaries, but he died young in 1792, and
Robert, with his two siblings, was brought
up on the Antiquaries' charity. Robert's date
of birth is unknown, and the date of his death,
allegedly of starvation, is given as 'about'
1849. He showed finished drawings at the RA
between 1803 and 1821, and was employed
by the *Gentleman's Magazine* and other
London-based journals. Now he is rather a
rare artist, little met with outside the principal
London collections, and work in this style
is often associated with the name of
T H Shepherd. As genre, it leads on to a
proto-realistic movement in English art
during the next decades, but Schnebbelie's
work has also a vital dimension of journalistic
reportage. The visual qualities of the present
drawing – its allusion to theatrical pageant
(viewed, as it were, from the second or third
row of the auditorium) – are satisfying, but
the work of art is not properly separable from
its social and temporal context. This is not
now easy to understand, but the image of
George IV's name in lights outside Drury
Lane (though it was the Theatre Royal, it was
closely associated with the Opposition élite),
and the conjunction of the Waterloo and
Coronation festivities, must have been
piquant. In the aftermath of the Queen's Trial
(for adultery with her 'Chamberlain'), and
against a background of the post-war
depression and popular riots, the King was
making an appeal to patriotism with a
simultaneous demonstration of his irresistible
hereditary rights and powers of patronage.

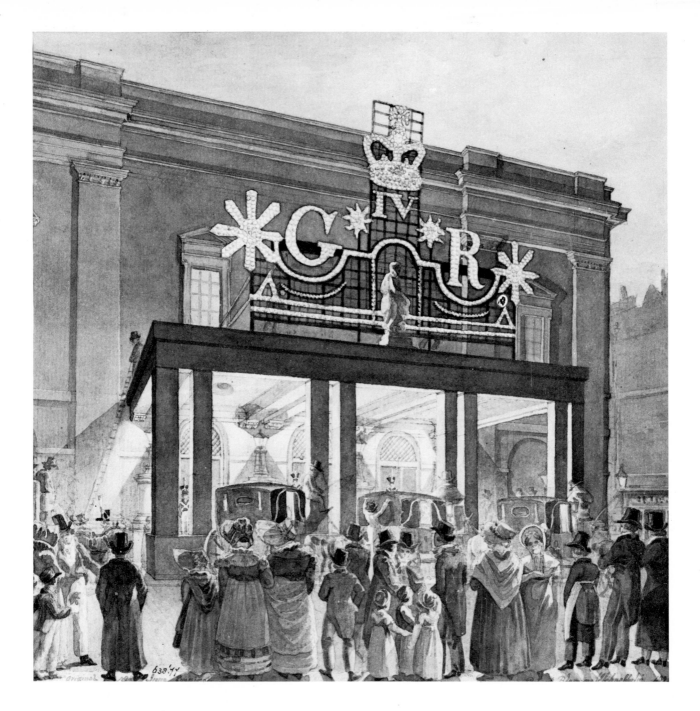

24 William Blake
1757–1827
The Angels hovering over the Body of Jesus in the Sepulchre

Pen and ink and watercolour on white wove, put down on a sheet of modern card; 42·2 × 31·4 cm.
Some fox marks removed and re-touched; stained by exposure.
Signed in ink lower left: *WB inv*; and inscribed lower right: *Exod: Cxxv. v 20*.
PROVENANCE Painted for Thomas Butts (d. 1846); Thomas Butts junr (d. 1862), his sale, Foster's, 29 June 1853, lot 90 (£3.17.6); by 1863, J C Strange; after 1876, Sydney Morse; Esmond Morse, by whose heir, G C Barton, presented to the Museum as part of the Morse Gift, May 1972. P.6–1972
EXHIBITED RA, 1808, no. 439 (*Christ in the Sepulchre, guarded by angels*); Blake's own exhibition, 1809, no. XIV (*Angels hovering . . .*).
LITERATURE William Blake, *Descriptive Catalogue . . .*, 1809, no. XIV; A Gilchrist, *Life of William Blake*, 1863, II, pp. 141, 238 no. 229; G Keynes, *William Blake's Illustrations to the Bible*, William Blake Trust 1957, no. 146 and p. x.

The passage in Exodus is from the detailed instructions given to Moses on Mount Sinai for the construction of the Tabernacle: 'And the cherubims shall stretch forth their wings on high, covering the mercy seat with their wings, and their faces shall look one to another: toward the mercy seat shall the faces of the cherubims be.' The mercy seat was to be placed upon the ark, and the Lord would commune with Moses from between the cherubim.

Blake seems to have borrowed this image to amplify the passage in St John chapter 20 verse 12, where Mary looks into the sepulchre and sees two angels in white sitting at the head and foot of the place where Jesus had lain. None of the Gospels offers an image of Jesus actually lying in the tomb, so Blake's drawing is thus not strictly an illustration so much as a commentary which suggests a connection between the Mercy Seat and the dead Christ – the latter representing the supreme act of mercy shown by God to redeem mankind. Although the life of Moses was in many respects an antitype of Christ's, there seems to have been no regular association between the golden cherubim and the angels at the tomb. W M Rossetti, compiling his list of Blake's drawings for Gilchrist, was confused by this novel typology, and failed to connect the drawing with the one shown at the 1809 exhibition. He also misread the reference to Exodus, and described the subject as 'a dead lord in the tomb, in perfect calm . . .'.

According to the *Descriptive Catalogue*, the *Angels hovering . . .* was a design that Blake wished was in fresco 'on an enlarged scale, to ornament the altars of churches'. There is accordingly a special compatibility between the design and its projected architectural setting. Probably Blake had in mind an association between the ark and the altar, and between the posture of the angels and the form of the ogee gothic arch. The outline of the angels also recalls the shape of hands composed in prayer. Such allusions and associations were certainly invited by the artist who regarded the Bible as a field for the free play of imagination. 'Why is the Bible more Entertaining and Instructive than any other book? Is it not because [it is] addressed to the Imagination, which is Spiritual Sensation, and but mediately to the Understanding or Reason?' (Blake, *Complete Writings*, ed. Geoffrey Keynes, 1966, pp. 793–4). Few of Blake's illustrative cycles adhere strictly to text or to orthodox typological schemes, and in some cases his drawings, like his poetry, can be as obscure to the imagination as to the understanding. But he intended his work to be widely accessible, whether on the printed page or as decoration for public buildings, and he believed that his visions were comprehensible to the 'Great Majority of Fellow Mortals' (ibid). At his best, Blake had a remarkable power of synthesizing the disparate and of unifying the fragmented ideas and images that accumulate in men's minds. His own work, in fact, has taken on something of the status that he himself attributed to the Bible and to the old masters of art and literature, and he stands as one of the great demotic artists of his generation, a genuine inventor whose work is held in common consciousness, part of the currency of mutual understanding.

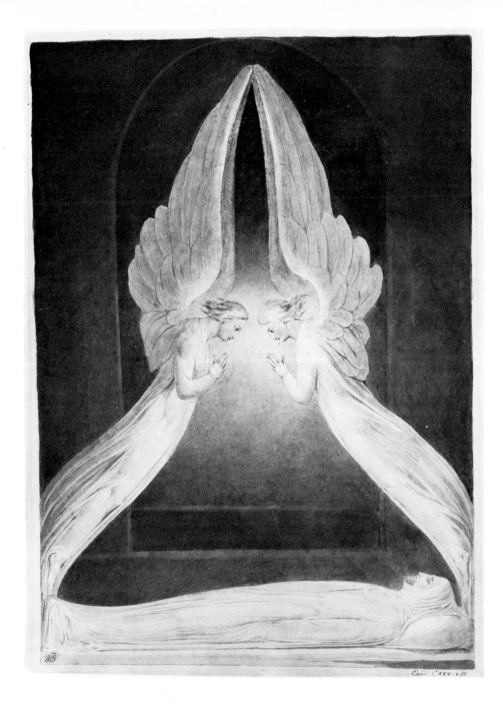

Exod. CXXV. v 20

25 John Varley
1778–1842
Snowdon

Pencil and watercolour on white wove; the margins trimmed, except lower left; 37·6 × 47·6 cm.
Some fading, especially in the sky; a marginal strip shows remains of former colour. The sheet marked with a central fold.
Signed or inscribed in pencil: *J. Varley*, on a tab, lower left.
PROVENANCE B Fleetwood Walker, from whom purchased by the Museum, Sept. 1924. P.52–1924
LITERATURE Iolo Williams, 1952, p. 226, fig. 362; M Hardie, 1967, II, p. 105, pl. 85. See also J Varley, *Treatise on the Principles of Landscape Design*, 1816, Introduction and General Observations.

Varley was probably the most devoted teacher of his generation. He taught both amateurs and aspirant professionals, and was enormously influential even beyond the reach of his own ebullient and articulate personality. He contributed prolifically to the annual exhibition of the Watercolour Society, and it was probably over the production of finished watercolours, well-planned and soundly executed, that he exercised his strongest influence.

The present drawing is of course 'unfinished' in the sense that it was not exhibitable in the state in which it was left. It is, however, artistically a complete conception, and I think there is no reason to suppose that Varley was incapable of seeing this. As it stands, the drawing communicates a direct sensual pleasure in its own physical properties – the light, wandering pencil and the clear, bright washes on the white paper. As a teacher Varley was intensely interested in the expertise of drawing, and his enthusiasm was celebrated; *Snowdon* shows how important in his art this pleasure of rapidity and magisterial precision was, and how it was controlled as the expression of a single idea. As he said in his *Treatise*: 'the practice of landscape in watercolours must assimilate to wit, which loses more by deliberation, than is gained in truth'.

As he got older, at least from about 1820, his reputation for eccentric dogmatism increased. This was not in his own field of graphic technology, but on the lunatic fringe of intellectual life, in astrology, palmistry and the summoning of spirits. Through these interests he became an intimate of William Blake, and was known as 'Vates' – the Master, prophet or poet. Such claims to special enlightenment I think grew quite naturally out of his professional work and opinions. His view was that the artist's main task was of classification and unification: firstly to grasp the nature of a scene, what it meant in terms of associations, and then to arrange it so as to enhance the leading idea, excluding or subordinating everything at variance. The artist was thus a sort of interpreter or medium, a student of signs in the sky or on earth; he had insight into the meaning and coherence of life, the character of parts and their relation to a significant whole. As a theory of art this was not eccentric: in Varley's case the uncharitable might observe that it led to old-fashioned and boring work. Though his style evolved and resembled increasingly the exhibition manner of Linnell and Palmer, his ideas of himself and his powers far outstripped his pictorial imagination. And that may be why, in an age that welcomed seers, he was called an eccentric more often than he was called a genius.

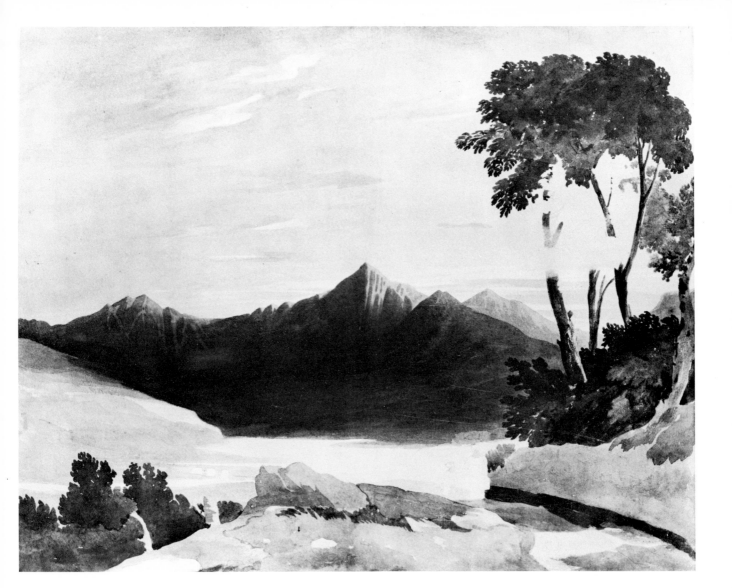

26 Peter de Wint
1784–1849
Still Life

Watercolour on wove; roughly trimmed and put down on card; 18 × 23·9 cm (maximum).

PROVENANCE Christie's, anon. sale, 5 Feb. 1892, lot 157 (with landscapes by A Stranger in lot 158), bt Philpot £3; G Douglas Thomson of Birmingham, from whom purchased by the Museum, Dec. 1926. P.1–1927

In the early nineteenth century still-life was not a common subject for watercolourists. The transparent medium was not obviously suitable for rendering the appearance and texture of objects in a successfully illusionist manner. Yet still-life, particularly as a vital part of the Dutch tradition, came in for its share of critical revaluation around 1800. Reynolds' view that the 'highest ambition' of the still-life painter was the 'minute representation of every part of these low objects' (*Discourse*, III, Dec. 1770) was qualified by Picturesque stress on chiaroscuro and tonal harmony. It was in this context that artists like de Wint became interested in still-life and demonstrated the aptness of watercolour in portraying 'the blended variety of mellow and harmonious tints' (Price, *Dialogue*, ed. 1810, III, 316). That is clearly the intention here, and there is no perceptible effort to distinguish the surface qualities of glass, earthenware or even wicker. Attention is focused on the play of light and on tonal unity. The physical qualities that require attention are those of the drawing itself: the quality of the wash lying on the paper, its colour, and the deft sureness of the artist's touch.

Like many of his contemporaries, de Wint was an active drawing master, and this circumstance encouraged him to evolve a demonstrative facility of technique.

Teaching seems to have been one of the most powerful influences on artists towards self-consciousness, making the artist think more of what he was doing, how he was doing it and how well: making him think what was special about himself, and what separated him from his pupil, and from other artists. De Wint may have taken these attitudes to an extreme. Technically, in his use of wet washes, run into one another with extraordinary finesse, he was one of the great virtuosi of watercolour. He regarded his own hand as utterly distinctive, and he explained his policy of not putting his name to his work by claiming that everything he did was 'signed all over'. This was not arrogance, but an attempt to express the extent to which the work of art had become for him a definitive and totally individual mark of his own personality.

27 J M W Turner
1775–1851
Hornby Castle from Tatham Church

Watercolour over pencil with touches of penwork; sponged, and heightened with gum and some bodycolour; on white wove (w/m J Whatman) put down on card; 29·2 × 43 cm.
Faded and light-stained; the margins torn and contaminated by glue; some small retouches in the margins. The condition of the drawing had deteriorated severely by the late nineteenth century. Ruskin referred to it in a letter to *The Times* of 1887, about the effect of exposure to light, as 'the most precious and delicate drawing it [the VAM] contains . . .'. See also W G Rawlinson, *Engraved Work of J. M. W. Turner*, 1908, I, p. 105.
PROVENANCE John Sheepshanks (on the basis of Redgrave's account, Sheepshanks was offered the whole set of *Richmondshire* drawings by the publishers Longman, and bought the *Hornby* for the price originally charged by Turner, 25 guineas. See Redgrave, *Memoir*, 1891, p. 290; given to the Museum by Sheepshanks, 1857. F.A.88

The drawing derives from pencil sketches on pp. 41 *verso* and 42 *recto* of TB cxlvii (1816), inscribed 'Lime Kiln on the . . . Bridge' [Finberg's reading], 'Alders', 'Meadow' and 'River shining thro' the Trees'. It was engraved by W Radclyffe in 1822 for Dr T D Whitaker's *History of Richmondshire . . .*, 1819–23, II, p. 263. Rawlinson, no. 185.

Hornby and Tatham are in the modern county of Lancashire. There is another Hornby in Yorkshire – the source of much confusion about Turner's view. The castle is 'a spectacular pele tower of the C 13 below, the early C 16 above'. From 1849 an 'even more spectacular castle' by Sharpe and Paley

was erected on the site for the financier, Pudsey Dawson. (See N Pevsner, *North Lancashire*, 1969, p. 147.)

Dr Whitaker was a distinguished antiquarian, and the leading local historian of the northern English counties. Turner had worked with him on several similar publications since 1800, but the *History of Richmondshire*, Whitaker's *magnum opus*, was the most ambitious. It is a brilliant, late summation of the full creative relationship that existed between draughtsmen and antiquarians from the eighteenth century into the first quarter of the nineteenth. In Turner's *oeuvre* the series has similarly, as Ruskin described, a culminating significance: 'I am in the habit of looking to the Yorkshire drawings as indicating one of the culminating points of Turner's career. In these he attained the highest degree of what he had up to that time attempted, namely, finish and quantity of form, united with expression of atmosphere, and light without colour. His early drawings are singularly instructive in this definiteness and simplicity of aim' (*Modern Painters*, I, quoted from Rawlinson, I, p. xxxviii).

In fact, the *Hornby* in particular shows much of Turner's extraordinary manipulative dominance over the watercolour medium. Ruskin was well aware of Turner's methods: 'There are lights bluntly wiped out of the local colour of the sky, and sharply and decisively on the foreground trees; others scraped out with a blunt instrument while the colour was wet . . . lights scratched out . . . others cut sharp and clear with a knife from the wet paper . . . and then for texture and air there has been much general surface-washing' (re a drawing of 1815;

quoted from Andrew Wilton, *Turner in the British Museum*, 1975, pp. 11–12).

Beyond this, the *Hornby* has been faulted for 'eccentricity' – the fact for example that the bridge simply fails to connect with the level of the road, and that the cat laps up the milk spilt by the passing donkey, though the milk would have been absorbed quickly into the ground (*Art Journal*, 1875, p. 364). The point of the latter Hogarthian incident is to provide a sense of the instantaneous present, in the bright foreground, in contrast with the antiquity of the Hornby pele in the blue distance. The device in various forms was employed often by Turner, and picked up by other artists including Constable in his *Stonehenge* (see no. 33). It is characteristic of Turner's anecdotal, associative habit of mind which throughout his career led him to introduce such small motifs into his compositions, to influence, almost subliminally, the free imaginative response of his audience.

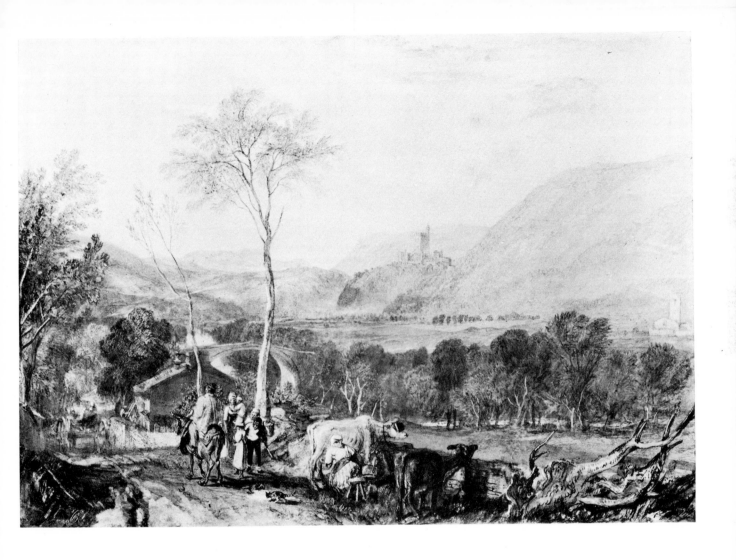

28 J M W Turner
1775–1851
Holy Island, Northumberland

Watercolour, with some penwork, bodycolour and gum heightening, cut and sponged; on white wove, put down on card and attached to a modern wash mount; 29 × 42·9 cm.

Slightly discoloured by light, old foxmarks in the sky with some discoloured retouches.

PROVENANCE By 1833, B G Windus; D R Davies; in 1908, A W Nicholson; presumably Christie's, 22 June 1917, lot 58 'the property of a lady', bt Sampson, 620 gns; Viscount Wakefield of Hythe, presented to the Museum by his widow, 1943. P.17-1943

EXHIBITED Egyptian Hall, Piccadilly, 1829; Moon Boys and Graves, Pall Mall, 1832-3 (see Finberg, *Life*, ed. 1961, nos. 335 and 412. See also exhibition list in Christie's, loc. cit.).

For this drawing Turner presumably looked back to sketches from the North of England sketchbook of 1797 (TB xxxiv, pp. 50-3). The drawing was engraved by W Tombleson for Charles Heath's *Picturesque Views in England and Wales*, 1827-38, Part IX, no. 3 (Rawlinson, 243). According to Henry Graves the publisher, the engravings were finished within a year of the drawings; Tombleson's plate is dated May 1830.

Easily the fullest and most intelligent account of the *England and Wales* drawings is given by Andrew Wilton in *Turner in the British Museum*, 1975, pp. 20-6.

The drawings were commissioned by Charles Heath (1785-1848), the leading publisher of fine engravings in London during the 1820s. Heath paid a high price for the drawings, and gave Turner complete freedom in the selection of subjects. The series was thus not a systematic survey of

England and Wales from a topographical point of view, nor were the subjects chosen primarily for their antiquarian interest. The prints were to be a published anthology of pictures by Turner, an extended treatment by him, as the greatest living painter of landscape, of places that he himself chose, and found significant. Commercially, the venture was a failure, despite the interpretative skill of the engravers, and the minute care that Turner gave to their supervision. Yet the drawings (exhibited in 1829 and 1832-3) and the prints enjoyed a *succès d'estime* among artists and connoisseurs. The chromatic exuberance of the drawings and the close attention to effects of weather, observed by nearly all critics of the series, affected the exhibition style of professional artists in the next decade. Skies, like the one in *Holy Island*, probably influenced the late finished watercolours of Constable, and Cox borrowed freely the compositions and colouristic harmonies for his own coastal and beach scenes. Technically, the series was the most convincing demonstration of the cult of virtuosity in handling the watercolour medium, and the most extensive available essay on landscape as a means of intellectual and emotional expression.

Holy Island in particular is a treatment of the Sublime, conceived as a fusion of the elemental and temporal. Elementally it pictures rock, and the buildings as a material extension of the rock, together with the sea and a vast, squally sky: the power and scale of these inanimate elements is contrasted with the figures and the sailing boat, whose existence is governed by them. Temporally, the drawing discusses the relation between the Priory – where St Aidan arrived from

Iona in AD 635 – and the immemorial rock and sea: the present again is represented by the activities of men and women. On the horizon to the right is a steamship,* a motif that contrasts with the sailing boat, as relatively independent of the elements, and that refers unmistakably to modernity – exciting, powerful, new, but dirty and mechanical in contrast to the purity of the winds.

* One of the earliest introduced by Turner into a finished picture cf. *Staffa Fingal's Cave*, RA 1832. But see the sketch TB ccclxiv-147; Wilton no. 93, dated there c. 1825.

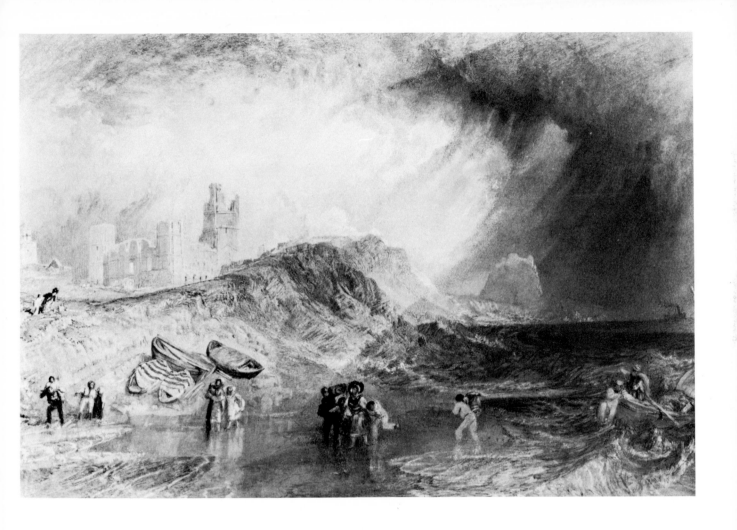

29 J M W Turner
1775–1851
Lyons at Sunrise or Sunset

Watercolour, with some penwork, cut, rubbed and sponged, on white wove (w/m partly illegible but clearly dated 1828) put down on card; 26·2 × 30·5 cm.
PROVENANCE Henry Vaughan (1809–99), by whom bequeathed to the Museum, 1900.
97–1900
LITERATURE Martin Butlin, *Turner Watercolours*, 1962, p. 68, pl. 25.

The date in the watermark, and its coincidence with Turner's last documented visit to Lyons in 1824–9 (see TB ccxxix and ccxxxv), are misleading. The drawing probably does not derive from that, nor from any subsequent visit to the city. The closest parallels are in an earlier sketchbook, TB cxcii, compiled on Turner's return from Italy in early 1820, which contains views of the city with water and multi-arched bridges. The cathedral is visible in some, and on one page Turner has noted the *11 arches* of the bridge. A page in the middle of the sequence was removed while the book was still in the artist's possession, but it would be unwise to presume that the present watercolour depended on a particular or topographically precise original. *Lyons* is rather a capriccio of the city, a fanciful evocation of its character and features, not a strict view: the position of the sun in relation to the water would anyway be impossible at Lyons, where the rivers flow broadly southward.

The main difficulty about the watercolour concerns its date and relation to the rest of Turner's work. Martin Butlin suggested 1840–5, and certainly some of the so-called 'sample' drawings of the 1841–3 Swiss series are similar in finish – in the use of dry hatching over liquid underwashes, pen and red ink accents, and in the use of dragged washes. The *Lausanne: Sunset* of c. 1841 (TB ccclxiv–350) is a good example, and a date about 1840 might be further supported by the fact that similar sheets of white paper, watermarked 1828, occur amongst the miscellaneous Venetian watercolours of 1837–41 (TB cccxvi). The problem is, however, to relate *Lyons* to any of the geographically coherent series of the early 1840s. As a subject it ought to belong with the *French Rivers*, but those drawings date from the late twenties into the thirties, and are mostly in gouache on blue or grey paper. We know that Turner originally intended to cover all the major French waterways, and it would be logical to suppose that Lyons, a great provincial capital situated near the confluence of Rhône and Saône, would be an important subject. We know also that Turner used material from earlier journeys for the *Rivers*, and that in 1828 he was gathering Rhône material without bothering to add much at Lyons. But there is nothing, as far as I know, which matches the *Lyons* in medium, size or style that could be connected with a Rhône or any *French River* project. The finished drawings made on commission, such as the *Marly* of 1831 for Munro of Novar, are quite different, and *Lyons* anyway is not a finished drawing in that sense. It has much more in common with the Swiss samples, and may have been made for a similar purpose, to develop a market for French watercolours after hopes for the complete *Rivers* petered out in 1835. This might imply a date before 1840, perhaps in the late thirties, but this is less likely than a date in the forties.

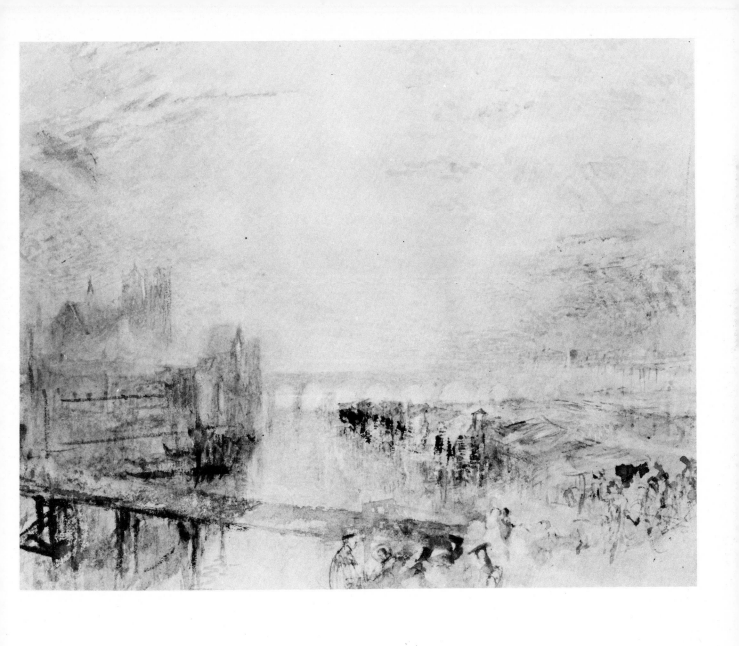

30 J M W Turner
1775–1851
On the Rhine

Watercolour and bodycolour on white wove, prepared with a grey wash, cut and sponged for the lights; 18·4 × 24·2 cm.
Another drawing of a fortified Rhineland town, on the back.
The lower right-hand corner torn and repaired, the margins torn and marked by glue.
PROVENANCE John Ruskin; Christie's, 15 April 1869, probably lot 24, bt Forster, 55 gns; John Forster, by whom bequeathed to the Museum 1876. F.103
LITERATURE Luke Herrmann, *Ruskin and Turner*, 1968, p. 99.

Ruskin supplied the catalogue entries for the Christies' sale of 1869. Lot 24 was 'On the Rhine, A grand glowing sketch, very characteristic of Turner's method of getting gold out of a grey ground'. The other lots bought by Forster were 27–32: 'Six sketches on the Rhine. Some drawn on the back of the paper as well; all of late time. 32 is of the Castle of Rheinfels'. Possibly the present drawing was one of the latter group; no sizes, however, were given.
 The size as well as the style and provenance of the present drawing led Luke Herrmann to associate it with the two Rhine sketches in the Ruskin School Collection at the Ashmolean (Herrmann, nos. 83 and 84). These are datable to 'about 1840', probably made as Turner travelled up the Rhine in August on his way to Venice. The subjects of the group appear to centre on the area around Rheinfels, St Goar and Katz, part of the fortified Rhineland, whose legends and localities provided much basic material for the *Sturm und Drang* romantics in Germany and England.

If the drawing was lot 24 in 1869, it is significant that Ruskin showed the more heavily-worked side of the sheet. *On the Rhine* is of course a moonlit scene, and the paper has been sponged over initially with a grey wash, then sponged again to produce the misty corruscating effect of the hazy moonlight over the water. On this basis, however, the drawing is of the slightest, the pencilwork extremely abbreviated and the local colour limited to the basic contrast of yellow and blue. It is a masterly summary of moonlight and antiquity, a late re-working of a theme Turner had side-stepped for his 1834 illustration of Walter Scott's early poem *Lay of the Last Minstrel* (1805). Scott's description of Melrose Abbey by moonlight was the definitive treatment of the theme in English *Sturm und Drang* poetry.

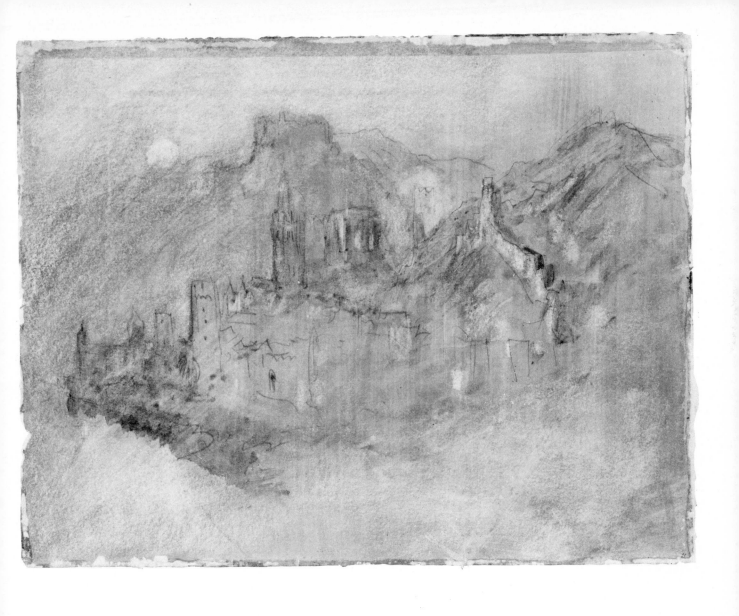

31 J M W Turner
1775–1851
A Gurnard

Watercolour and gouache on grey wove;
19 × 27·6 cm (irregular).
PROVENANCE John Ruskin; Fine Art Society;
bt R Clarke Edwards, 6 May 1900, and
bequeathed by him to the Museum, June
1938. P.18–1938
EXHIBITED Fine Art Society, 1878, no. 109;
1900, no. 65; Royal Academy, *Turner*,
1974–5, no. B.125, see also entry nos. 437
and 518.
LITERATURE Martin Butlin, *Turner
Watercolours*, 1962, p. 64, pl. 23.

Ruskin presumably acquired the *Gurnard*,
together with the drawing which he showed
as no. 108 at the Fine Art Society in 1878,
as a study for *Slavers throwing overboard the
Dead and the Dying – Typhoon coming on*
(RA 1840, now Boston Museum of Fine Arts),
a picture which Ruskin's father gave to him
for the New Year of 1844. It was Ruskin's
policy to acquire sketches connected with
finished works by Turner in his collection,
sketches which he regarded as of independent
value. He wrote to his father after Turner's
death in December 1851: 'I understand the
meaning of these sketches, and I can work
them up into pictures in my head, and reason
out a great deal of the man from them . . .'
(Cook and Wedderburn, XIII, p. xxiii).
'Whenever the colours are vivid – and laid
on in many patches of sharp, *blotty* colour –
not rubbed – you may be sure the drawing is
valuable. For Turner never left his colours
fresh in this way unless he was satisfied; and
when *he* was satisfied, *I* am' (ibid, p. xxv;
these sentences refer directly to the Swiss
mountain drawings of the early forties).
 For the Fine Art Society in 1878 Ruskin
catalogued his *Gurnard* as 'Study for the

Slaver. Fish looking up to the sky (modern
philosophy)'. This description is interesting.
The verbal style of it actually echoes that of
Turner's terse and parenthetical way of titling
exhibited pictures in the last years of his
activity, but the content is Ruskin's own,
quite separate from the meaning of the
Slavers picture. I am not sure what he
meant by 'modern philosophy', which ideas
and which thinkers, but the image of a fish
gazing at the sky is surely contemptuous.
Ruskin's teaching was essentially concerned
with looking at things (including of course
the sky as phenomenon): 'The truth of infinite
value that he teaches is *realism* – the doctrine
that all truth and beauty are to be attained
by a humble and faithful study of nature,
and not by substituting vague forms, bred
by imagination on the mists of feeling, in
place of definite, substantial reality'
(*Westminster Review*, lxv, April 1856, p. 626;
review of *Modern Painters*, vol. III).
 The fish, as emblem of Ruskin's
philosophical opponents, might well be
capable of apprehending the sky only as a
vague form, and its view would be affected
by the mists of feeling necessarily attendant
on its miserable, expiring condition. Ruskin's
own view of the natural world tended to be
joyous and celebratory, feelings which Turner
pre-eminently excited in him. The comment
on the *Gurnard* was no doubt flippant as well
as contemptuous, but it sprang precisely from
Ruskin's uniquely sympathetic pleasure in
Turner's art.

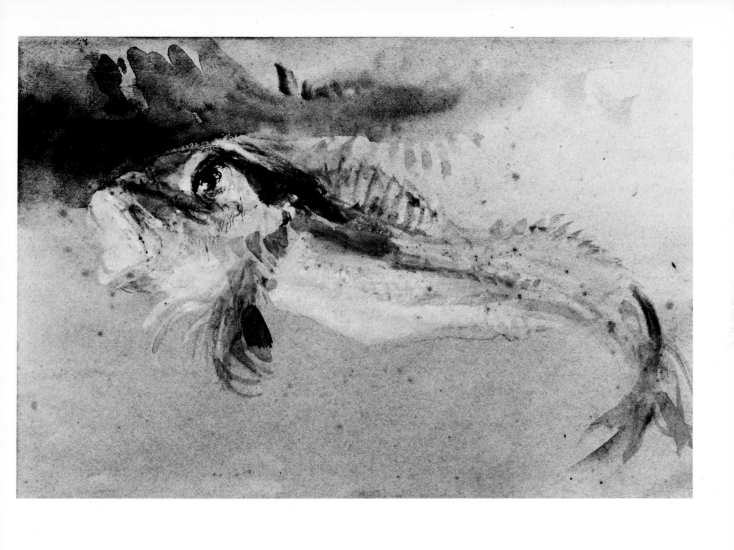

32 John Constable
1776–1837
Old Sarum

Watercolour, cut, rubbed and sponged, with some penwork; on white wove (w/m J. Whatman 1832), pieced out in the right margin and put down on card (w/m J. Whatman 1830), ruled with a gold line for a mount; 30·2 × 48·8 cm.

PROVENANCE Bequeathed to the Museum of Isabel Constable, daughter of the artist, 1888. 1628–1888

EXHIBITED RA, 1834, no. 481, 'The Mound of the City of Old Sarum, from the South'; Tate Gallery, 1976, no. 311.

LITERATURE G Reynolds, *Catalogue of the Constable Collection*, VAM, 1960 and 1973, no. 359, pl. 265; Louis Hawes, *John Constable's Writings on Art*, PhD dissertation, Princeton, 1963, University Microfilms Ann Arbor, Michigan, Reprint 1964, esp. ch. IV.

Constable offered a suggestive interpretation of *Old Sarum* in the 'Commentary' he wrote to accompany the mezzotint in *English Landscape*:

'The subject of this plate, which from its barren and deserted character seems to embody the words of the poet – "Paint me a desolation," – is grand in itself, and interesting in its associations, so that no kind of effect could be introduced too striking, or too impressive to portray it; and among the various appearances of the elements, we naturally look to the grander phenomena of Nature, as according best with the character of such a scene. Sudden and abrupt appearances of light, thunder clouds, wild autumnal evenings, solemn and shadowy twilights, "flinging half an image on the straining sight," with variously tinted clouds, dark, cold and gray, or ruddy and bright, with transitory gleams of light; even conflicts of the elements, to heighten, if possible, the sentiment which belongs to a subject so awful and impressive.

"*Non enim hic habemus stabilem civitatem*". The present appearance of Old Sarum – wild, desolate, and dreary – contrasts strongly with its former greatness. This proud and "towered city," once giving laws to the whole kingdom – for it was here our earliest parliaments on record were convened – can now be traced but by vast embankments and ditches, tracked only by sheep-walks: "The plough has passed over it." . . . The site now only remains of this once proud and populous city, whose almost impregnable castle, and lofty and embattled walls, whose churches, and even every vestage of human habitation, have long since passed away' (quoted from A Shirley, *The Published Mezzotints of David Lucas . . .*, 1930, pp. 258–9).

The language here is that of the Sublime, derived about equally from Burke and from Archibald Alison. The Burkeian, sensationist depiction of the Sublime is evident in Constable's emphasis on particular features of the scene which produce a direct effect of awe – the 'sudden and abrupt appearances of light, thunder clouds, wild autumnal evenings, solemn and shadowy twilights', etc. The influence of Alison, whose *Essays on the Nature and Principles of Taste* Constable greatly admired, underlies the use of the word 'association'. Alison had argued that aesthetic experience was founded on the associative power of the human mind, that it was 'when we are absorbed in this powerless state of reverie, when we are carried on by our conceptions, not guiding them, that the deepest emotions of beauty or sublimity are felt' (quoted from Hawes, p. 91). Alison thus rationalized a form of aesthetic response, and described a state of physical lassitude combined with intense mental activity, that was of real psychological insight: the experience was one that would have been recognized by such disparate aesthetes as Beckford in 1782 or Ruskin sixty years later.

Associative response was peculiarly appropriate to landscape that was historically significant, and it was within the broadly Alisonian analysis that antiquarian draughtsmanship developed its highest aesthetic potential. Constable accordingly invites a freely associative response to the desolation of Old Sarum in contrast to its former greatness as a proud and towered city, the source of law and parliamentary stability. In the aftermath of the Great Reform Bill of 1832, this image, as Sir Thomas Lawrence recognized, was prophetic of the disaster that Constable and the Tories foresaw from the disenfranchisement of the Rotten Boroughs like Old Sarum. Constable spoke in 1831 of the 'tremendous attack on the constitution of the country' which 'goes to give the government into the hands of the rabble and dregs of the people, and the devil's agents on earth, the agitators' (C R Leslie, *Memoirs of the Life of John Constable R.A.*, 1843, p. 77)

But as an instance of how the freely associating mind could enrich the subject by self-contradiction, reversing itself and following an opposite train of thought, he introduced the motif of the shepherd and his flock. This is either an emblem of good and godly government, invoked elegiacally as consistent with the old parliamentary order of Sarum, or it is of opposite significance. He concluded his commentary by quoting a dozen lines of James Thomson's 'Summer' from

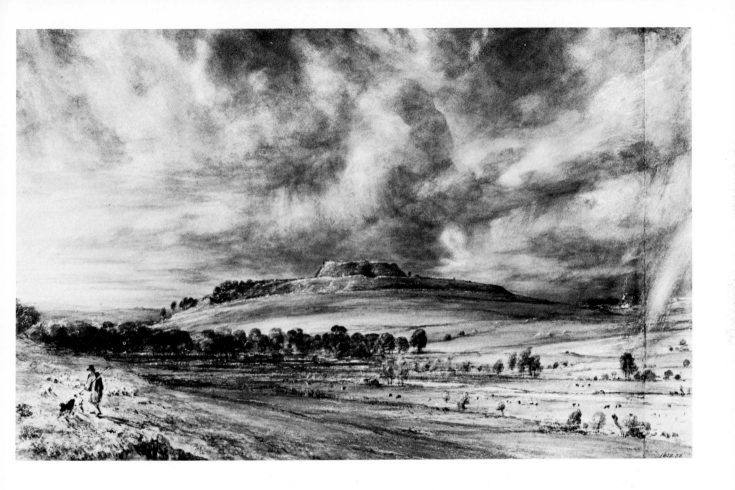

The Seasons, with the comment that 'The
beautiful imagination of the poet . . . when he
makes a spot like this the haunt of a shepherd
with his flock, happily contrasts the
playfulness of peaceful innocence with the
horrors of war and bloodshed, of which it was
so often the scene' (quoted from Shirley,
p. 259).

33 John Constable
1776–1837
Stonehenge

Watercolour, cut, rubbed and sponged on white wove, pieced out in the left and upper margins, and put down on card, ruled in gold for a mount; the hare, lower left, is on a separate piece of paper, pasted on; 38·7 × 59·1 cm.
Inscribed on the mount: '*The mysterious monument . . .*' (see below).
PROVENANCE Bequeathed to the Museum by Isabel Constable, daughter of the artist, 1888. 1629–1888
EXHIBITED RA, 1836, no. 581; Tate Gallery, 1976, no. 331.
LITERATURE G Reynolds, *Catalogue of the Constable Collection*, VAM, 1960 and 1973, no. 395; Louis Hawes, *Constable's Stonehenge*, VAM, 1975.

Louis Hawes has given a full account of *Stonehenge*, and reference to his monograph is necessary for a proper understanding of this rich and complicated work of art.

Like *Old Sarum*, the drawing is an exercise in the Sublime. The example of Stonehenge was cited by Burke to illustrate his correlation of Difficulty and Greatness as productive of the Sublime (*Philosophical Enquiry . . .*, 1757, Pt II, Section XII). It was exhibited with the following statement:

'The mysterious monument of Stonehenge, standing remote on a bare and boundless heath, as much unconnected with the events of past ages as it is with the uses of the present, carries you back beyond all historical records into the obscurity of a totally unknown period.'

To create the necessary effect Constable drew on practically the entire vocabulary of the Sublime, invoking the concept of infinity in his depiction of the plain, and the awesome power of the elements in his vast, dark sky. In this setting, the magnitude and weight of the stones are emphasized by contrast with the small human figures. It is a scene, as Constable pointed out in the accompanying quotation, which actually baffles association but at the same time irresistibly demands it. Accordingly, he has constructed a careful system of motifs, correspondences and contrasts which individually and together reinforce the basic sensory impression of vastness and unknowable infinity. The rainbows, arching in the first sunshine after the storm, carry the prehistoric and Biblical suggestions of the Flood and God's promise to Noah. The man sitting on the fallen stone casts a shadow, a symbol of transience, on a stone which is of immemorial age. The hare in the foreground and the baggage waggon in the distance, link the concept of movement with that of time, like the minute and hour hands of a clock. The hare also may carry a suggestion of danger and death: Constable would have known Turner's plate for W B Cooke's *Views in Sussex*, 'Battle Abbey, the spot where Harold fell', which has a hunted hare in the foreground, symbolic of the king's death. This may allude to the common contemporary belief that Stonehenge had been the site of Druidical sacrifices.

The composition is organized on a plan of two diagonals crossing in the centre. One diagonal runs from the hare to the waggon, and the other from the man on the fallen monolith to the left-hand rainbow. The monument is at the centre. Thematically, the diagonals express transience, and the centre expresses permanence.

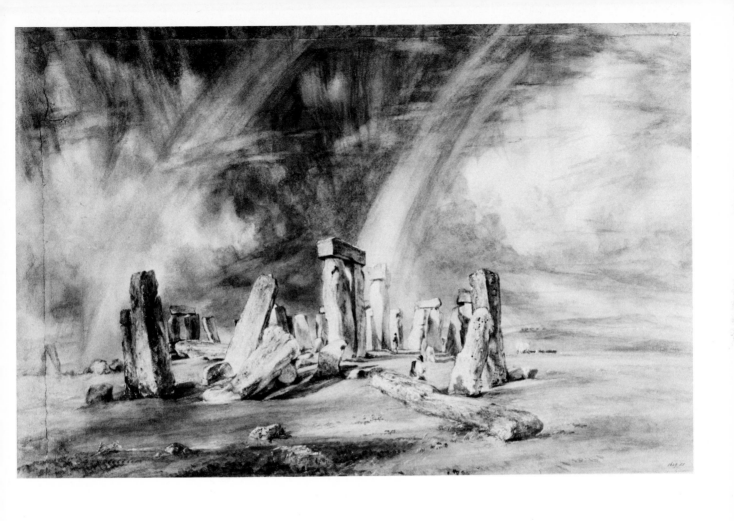

34 David Cox
1783–1859
The Challenge

Watercolour and some gouache on white wove, put down on card; 45·5 × 66·6 cm. Inscribed in pencil *verso*, probably by the artist: *on the Moors near Bettws y Coed – N.W.*
PROVENANCE Rev Chauncy Hare Townshend, by whom bequeathed to the Museum, 1869. 1427–1869
EXHIBITED Probably Society of Painters in Watercolours, 1856, no. 179, *On the Moors near Bettws-y-Coed.*
LITERATURE Trenchard Cox, *David Cox*, 1947, p. 110, repro. p. 120.

At the Watercolour Society exhibition of 1856 two of David Cox's drawings* were hung on either side of J F Lewis' *Encampment in the Desert of Mount Sinai* (no. 134). Ruskin discussed the minute realism and brightness of the Lewis: 'Note first the labour in the sky. The whole field of it is wrought out gradually with touches no larger than the filaments of a feather. It is, in fact, an embroidered sky – Penelope's web was slight work compared to it . . . The purpose of this is to get the peculiar look of heat haze, and depth of colour, with light, which there is in all skies of warm climates.'

He finished his notice with the following remark: 'It will be observed that on each side of this brilliant and delicate picture is hung a drawing of excessive darkness and boldness, by David Cox. This was thoroughly well judged – there is no rivalship – but a kindly and effective contrast. The two drawings of English moors . . . gain in gloom

* Cox had only five drawings in the same part of the exhibition as Lewis', and, judging by their titles, *On the Moors near Bettws-y-Coed* was probably one of those discussed by Ruskin.

and power by the opposition to the Arabian sunlight; and Lewis's finish is well set off by the impatient breadth of Cox' (Cook and Wedderburn, *Works of John Ruskin*, 1903–12, XIV, pp. 76–8).

The contrast was indeed significant, pointing to deep division in the creative purpose of artists in the fifties. Lewis, like the Pre-Raphaelites, was interested in finish as 'added truth', and his pictures celebrated the bright and abundant variety of the real world. Cox's late drawings, on the other hand, were primarily intellectual in conception; the landscape was a vehicle for the expression of a state of imaginative excitement, and the sense of immediacy was transmitted by the speed and dash of the execution.

Cox's was the traditional, even the old-fashioned view in the 1840s and 50s. He had shown his fundamental commitment to Burke's definition of the nature and effects of Beauty and Sublimity in his *Treatise on Landscape Painting in Watercolour* of 1813: 'Abrupt and irregular lines are productive of a grand or stormy effect; while serenity is the result of even and horizontal lines, where no roughness or intersections appear, to invade the mild harmony of beauty.' In his later work Cox turned increasingly to the Sublime, and drawings like *The Challenge* were based unmistakably on a conception of the awesomeness and power of the elements. The landscape was vast, black and indistinct, and the bull was itself an emblem of crude male power. The attitude suggested an elemental defiance beyond that of human beings, beyond the pathetic raging of King Lear, and closer probably to the sublime defiance of the Miltonic Satan. The theme was familiar in romantic art and letters, but

Cox's treatment provided it with an original and extraordinarily convincing embodiment almost exactly a hundred years after the first publication of Burke's *Philosophical Enquiry into the Origin of our Ideas of the Sublime and the Beautiful.*

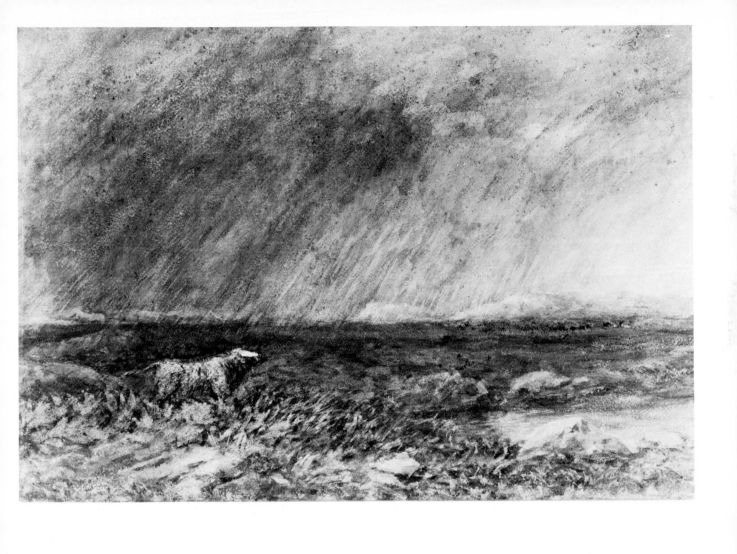

35 Richard Dadd
1817–1886
Sketch to illustrate the Passions: Patriotism

Pen and ink and watercolour on cream wove
put down on card; 36·2 × 25·9 cm.
Signed and inscribed along the lower margin:
Sketch to illustrate the Passions: Patriotism.
by Richard Dadd. Bethlehem Hospital. London
May 30ᵗʰ 1857. St. George's in the Fields.
The full text of the commentary (without the
place names from the map) is transcribed in
Greysmith, Appendix B, pp. 134–6.
PROVENANCE Dr William Charles Hood
(1824–70; knighted 1868); his sale Christie's,
28 March 1870, lot 316, bt John Forster
(21 gns), by whom bequeathed to the
Museum 1876. F.59
EXHIBITED Tate Gallery (Arts Council),
1974, no. 165 (illus.).
LITERATURE David Greysmith, *Richard Dadd
The Rock and Castle of Seclusion*, 1973,
pp. 84–6, repro. in colour pl. 84;
Patricia Allderidge, *The Late Richard Dadd*,
Tate Gallery, 1974, pp. 40, 110–11.

The first signs of Richard Dadd's derangement
were observed by Sir Thomas Phillips
(1801–67) in the course of a tour through
Europe into Egypt and Palestine in 1842–3.
Phillips, the patron, sought medical advice
in Paris on the return journey, and Dadd,
suspicious of observation, set off home to
London by himself. In London from the end
of May 1843, he apparently settled down to
work, but his condition gave cause for alarm,
and further advice from the leading
specialists was sought. The opinion was that
the patient was not responsible for his actions,
and should be subject to restraint. Care and
supervision were accordingly undertaken by
Robert Dadd, the father, and the pair left
London for Cobham in Kent on 28 August
1843. That evening Richard Dadd persuaded

his father out for a walk and murdered him
by stabbing and slashing at his throat with a
razor; he then fled to France. Dadd believed
himself to be the instrument of the will of
Osiris, and he identified his father with
Satan. Osiris in Egyptian theology was the
protagonist of Good, and was associated in
some sources with the Sun. The governor of
the asylum of Clermont in France, where
Dadd was held before extradition to England
in 1844, recorded: 'His employment all day
is to stand in the courtyard, with upturned
eyes gazing at the sun, which he calls his
father' (quoted from Greysmith, p. 61).
These delusions and the disposition to violence
remained with him for the rest of his life.

The *Passions* series of watercolours was
done in the Bethlehem Hospital under the
auspices of the enlightened physician Charles
Hood. Most of the 'sketches' are readily
comprehensible on the simple level of literary
illustration or genre, sometimes derivative in
iconography, but always inventive within
the broad tradition of moral *tableaux*.

Patriotism is rather exceptional; it was the
last of the series, and the composition, as
David Greysmith noticed (p. 61), was almost
certainly influenced by C R Leslie's
Uncle Toby and the Widow Wadman (Tate
Gallery and VAM). More profoundly, I think
the whole view of patriotism as a ruling
passion for military history derives from
Sterne. The veterans in the drawing are
clearly meant to have an eighteenth-century
look, and the Olabolika campaign recalls the
European and colonial wars of position in the
age before Napoleon. Uncle Toby and
Corporal Trim were mainly concerned with
Marlborough's campaigns, but their esoteric
maunderings about generals and places, and

the intricacies of siege operations, become in
the book cumulatively as fantastic as the
moral geography of Olabolika. In Dadd's
text, the sudden disruption of narrative
illusion is thoroughly Shandian: 'The Citadel
received the first blow . . . and it surrendered
on condition that there should be an
impertinent map made of it, with explanations
and two drawings of Two Veteran Heads
engaged in conversation about it, at the
bottom. This task it will be seen is not so
well done, as it might be by better hands.'
Sterne of course worked within a
well-established European tradition, and there
were numerous other sources and analogues
of the idea of a map with places named after
human qualities. Patricia Allderidge has
cited the description of the Chatham
wargames in *Pickwick Papers*, and emphasized
the personal relevance to Dadd both of the
Chatham manoeuvres in 1837, and of many
of the names on the map (e.g. 'Lunatic
Asylum called Lostwithal'). The drawing is
certainly crazy, and Dadd certainly referred
to himself in it, but the importance of
realizing the basic Shandyism of the
conception is that it enables the work to be
seen as part of an artistic genre which used
craziness as an instrument of conscious
humour. The disjointed style of the
commentary, the twists of sense and the
sudden hits at a reality outside the fiction,
were essentially part of that genre, not
necessarily symptoms of the artist's own
derangement. I think Dadd, who was
well-read, understood this exactly, and it is
therefore unwise to treat the drawing, and
the references to the devil, as a form of
self-revelation. The spoof works at too many
levels, the artist's mind is too agile to be

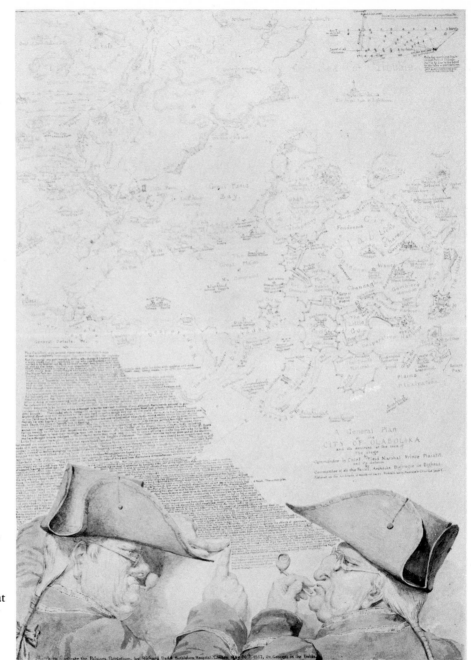

caught, and is ultimately quite indifferent to our interpretations: 'The scale in the Corner will enable you to overcome any difficulties of size or distance in the map, being constructed so that it is impossible to understand it and therefore you may say what you please about it. In all other matters please to consult the Angel who enjoys the reputation of knowing best and being most truthful.'

36 John Ruskin
1819–1900
Zermatt

Pencil, pen and watercolour with some gouache on white wove (w/m J. Whatman); 27·3 × 38 cm (irregular).
The edges of the sheet torn and the surface pulled away by the glue of a former mount.
Inscribed by the artist in ink lower right: *Zermatt*.
PROVENANCE Purchased from an unknown source by Harold Hartley 'several years before he sold it to the Museum' in March 1921. P.15-1921
EXHIBITED Royal Academy, 1919, no. 335.

Ruskin was at Zermatt between 2 and 10 August 1849, and I would be inclined to ascribe the present drawing to that visit, mainly by analogy with finished rectangular drawings of the Matterhorn and the Bernese Alps which are firmly datable 1849 (see for example *Works of John Ruskin*, ed. Cook and Wedderburn, 1903-12, IV, photogravure D.). The influence of J D Harding, Ruskin's drawing master in the early forties is, however, evident in some of the pencilling, a factor which would support a date of 18-19 July 1844, during Ruskin's first visit to Zermatt.

As Paul Walton has argued, Harding's tuition guided Ruskin towards the basic perception that beauty was to be found and studied in, rather than composed from, Nature (P H Walton, *Drawings of John Ruskin*, Oxford, 1972, p. 50). This discovery was fundamental to the rest of Ruskin's work and teaching, and it came to him as a moment of physical and mental *éclaircissement* in a lane near Fontainebleau in 1842:
'I lay feverishly wakeful through the night, and was so heavy and ill in the morning that I could not safely travel and fancied some bad sickness was coming on. However,

towards twelve o'clock the inn people brought me a little basket of wild strawberries; and they refreshed me, and I put my sketch-book in pocket and tottered out, though still in an extremely languid and woe-begone condition; and getting into a cart-road among some young trees where there was nothing to see but the blue sky through their branches, lay down on the bank by the roadside to see if I could sleep. But I couldn't, and the branches against the blue sky began to interest me, motionless as the branches of a tree of Jesse on a painted window . . .
'Languidly, but not idly, I began to draw it; and as I drew, the languor passed away: the beautiful lines insisted on being traced, – without weariness. More and more beautiful they became, as each rose out of the rest, and took its place in the air. With wonder increasing every instant, I saw that they "composed" themselves by finer laws than any known of men. At last, the tree was there . . . an insight into a new silvan world.
'Not silvan only. The woods which I had only looked on as wilderness, fulfilled I then saw, in their beauty, the same laws which guided the clouds, divided the light, and balanced the wave. "He hath made everything beautiful, in his time," [Ecclesiastes, III, xi] became for me thenceforward the interpretation of the bond between the human mind and all visible things . . .' (*Praeterita* II; Cook and Wedderburn, XXXV, 313-15).

Lassitude, the fear of consumption, and the onset of depressive phases from the late forties, formed the background from which the recurring stimuli of art and the physical world roused him into the jubilance of perception and creativity. One of the best known of these moments was his first view

of the Alps from a terrace at Schaffhausen: 'I went down that evening . . . with my destiny fixed in all of it that was to be sacred and useful. To that terrace, and the shore of Lake Geneva, my heart and faith return to this day, in every impulse that is yet nobly alive in them, and every thought that has in it help or peace' (*Praeterita* I; Cook and Wedderburn, XXXV, 116).

Ruskin was at Zermatt in 1849 primarily to make studies for use in the fourth volume of *Modern Painters*. On this project he deployed the full resources of his geological knowledge in the graphic depiction of mountain structure. In *Zermatt* the attention is focused on the formation of the peaks, folded up into pinnacles, and descending steeply on the eroded flanks into the valley. The mountains are apprehended as evolving creations, analogous to the wood of the house in the foreground, which is worn into lines and broken into fragments by similar exposure to the elements. Ruskin was acutely conscious that the time-scale of geological evolution extended far beyond the date of the Biblical creation, and was destructive of simple faith, but the tendency of his argument in *Modern Painters* IV was that the essential insights of religion and morality were deepened by the wonder and fear of mountains. The element of fear he illustrated with examples drawn from the life of the people, one of them from Zermatt:
'We are walking, perhaps, in a summer afternoon, up the valley of Zermatt (a German valley), the sun shining brightly on grassy knolls and through fringes of pines, the goats leaping happily, and the cattle bells ringing sweetly, and the snowy mountains shining like heavenly castles far above. We see, a little

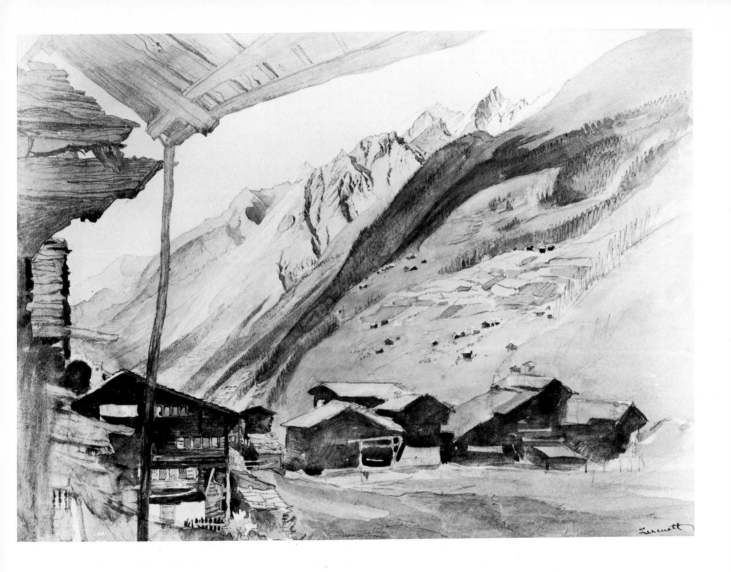

way off, a small white chapel, sheltered behind
one of the flowery hillocks of mountain turf;
and we approach its little window, thinking
to look through it into some quiet house of
prayer; but the window is grated with iron,
and open to the winds, and when we look
through it, behold – a heap of white human
bones mouldering into whiter dust!'
('Mountain Gloom', *Modern Painters*, IV,
1856; Cook and Wedderburn, VI, 395).

37 Samuel Palmer
1805–1881
In a Shoreham Garden

Watercolour and gouache (the latter in relief) on grey wove, blind stamped upper left: *Crayon Papers/Fast Colours/Creswick*, put down on thin card; 28·2 × 22·2 cm. Some old losses in the impasto. Inscribed extensively in pencil *verso* by Martin Hardie, with notes mainly relating to the 1926 exhibition.
PROVENANCE By descent to A H Palmer; from whom purchased by the Museum, 1926. P.32–1926
EXHIBITED VAM, 1926, no. 62.
LITERATURE A H Palmer, *Life and Letters of Samuel Palmer*, 1892, p. 48, as a companion of the *Magic Apple Tree* (Fitzwilliam); Geoffrey Grigson, *Samuel Palmer The Visionary Years*, 1947, no. 78, pp. 57, 88–90. Dated by Grigson c. 1829.

The crucial influences on Palmer in his Shoreham period were Blake, the Bible and Milton. He described the influence of Blake himself:
'I sat down with Mr Blake's Thornton's *Virgil* woodcuts before me, thinking to give to their merits my feeble testimony. I happened first to think of their sentiment. They are visions of little dells, and nooks, and corners of Paradise; models of the exquisitest pitch of intense poetry. I thought of their light and shade, and looking upon them I found no word to describe it. Intense depth, solemnity, and vivid brilliancy only coldly and partially describe them. There is in all such a mystic and dreamy glimmer as penetrates and kindles the inmost soul, and gives complete and unreserved delight, unlike the gaudy daylight of this world. They are like all that wonderful artist's works the drawing aside of the fleshly curtain, and the glimpse which

all the most holy, studious saints and sages have enjoyed, of that rest which remaineth to the people of God' (quoted from G Grigson, *Samuel Palmer's Valley of Vision*, 1960, p. 18).
Less well understood is Palmer's relation to the Picturesque. He annotated Richard Payne Knight's *Analytical Enquiry into the Principles of Taste* (1805), and though, like other artists, he disliked the arrogance of the connoisseur, we know thus that he was acquainted with the theories of the Herefordshire Picturesque. Picturesque, indeed, is one of the words that Palmer applied to the church spire landscapes that he painted in such works as the *Hilly Scene* (Tate Gallery) and *The Magic Apple Tree* (Fitzwilliam): 'Look for picturesque combinations of buildings, and elegant spires, and turrets for backgrounds' (A H Palmer, 1892, p. 45). His 'primitive' cottages, barns with mossy roofs, and oak trees in Lullingstone Park, were described and painted with picturesque attention to the intricacy and variation of their textures, and the sheep nestling in their hollows in deep lanes recall Uvedale Price's description in the *Essay on the Picturesque* of 'hollows . . . frequently overgrown with wild roses, with honeysuckles, periwincles, and other trailing plants . . . hanging loosely over one of these recesses, opposed to its deep shade, and mixed with the fantastic roots of trees . . . In the summer time these little caverns afford a cool retreat for the sheep; and it is difficult to imagine a more beautiful foreground than is formed by the different groups of them in one of these lanes; some feeding on the patches of turf . . . some reposing in these deep recesses, their bowers "O'er canopied with luscious

eglantine" ' (London, 1810 edition, pp. 28–9).
Direct observation of this sort underlay many of the pictorial idylls of Shoreham.
Palmer's Christianity, and his thorough knowledge of the Bible and *Paradise Lost*, pervade the Shoreham pictures. Sheep and shepherds, of course, have Biblical as well as picturesque significance, and the idea of a garden is similarly charged with association. The Shoreham garden is a type of the Garden of Eden. Palmer wrote to John Linnell in December 1828: 'Terrestrial spring showers blossoms and odours in profusion, which, at some moments, "Breathe on earth the air of Paradise": indeed sometimes, when the spirits in Heav'n, earth itself, as in emulation, blooms again into Eden; rivalling those golden fruits which the poet of Eden sheds upon his landscape, having stolen [them] from that country where they grow without peril of frost, or drought, or blight – "But not in this soil" '(A H Palmer, p. 175). The garden is a 'corner of Paradise', and here it is emphatically in its spring time. Whether there is symbolism beyond this is difficult to tell, but the subject of the picture is always described as an apple tree in blossom; there is the figure of a clothed woman in the background and perhaps the stem of the creeper climbing up the post in the right foreground suggests a serpent. I think it is impossible that Palmer could have painted this without intending a reference to the story of the Fall: the picture would thus be about the attainment of a pre-lapsarian innocence and purity in a paradisal modern garden. Blossom, which precedes the fruit, is an emblem of virginity, but the woman is clothed because she lives in the post-lapsarian present.

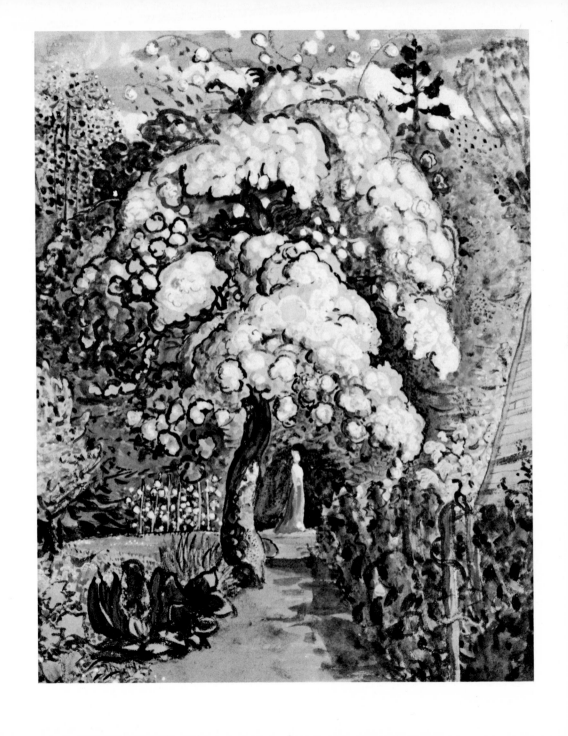

38 Samuel Palmer
1805–1881
Tintern Abbey

Pen and ink and watercolour with some pencil, and gouache heightening, on white wove; 37 × 48·6 cm.
Engrimed, and stained by exposure.
Inscribed in pencil lower right *recto*: *47* (presumably the page number in Palmer's sketch-block).
PROVENANCE J Meyrick Head; presented to the Museum by his widow, July 1919.
E.1902-1919

Palmer was at Tintern on his return from Wales in August 1835. He wrote to George Richmond:
'we have this evening got into a nook for which I would give all the Welsh mountains, grand as they are; and if you and Mrs Richmond could but spare a *week*, you might see Tintern and be back again . . . – and such an Abbey! the highest Gothic; trellised with ivy, and rising from a wilderness of orchards, and set like a gem amongst the folding of woody hills' (quoted from A H Palmer, *Life and Letters of Samuel Palmer*, 1892, p. 188).

Throughout his career Palmer produced extremely careful and detailed landscape studies, often with central passages highly finished in colour, and the periphery fading off into the paper with fainter and looser pencilling. These studies recall Palmer's connection with the Varley circle, especially Cornelius Varley and Joshua Cristall, and with the 'Extollagers', who included Robert Hills (see Martin Mardie, 'Robert Hills: "Extollager", ' *Old Water Colour Society Annual*, XXV, 1947, pp. 38–40). The effect, which was probably based on the observation of the way that the eye, or any lens,* focuses most sharply on the central area of vision,

became formalized during the late twenties in the landscape vignette. The vignette was itself a sort of allegory of creation – 'the objects come out of nothingness into being' (P G Hamerton on Turner; quoted from W G Rawlinson, *Engraved Work of J. M. W. Turner*, 1908, I, p. liii) – an allegory that transformed the art of drawing on a blank sheet of paper into a ritual of the Creation in Genesis. Palmer certainly thought of his work as a parallel to worship, and had a particular reverence for the tools of his own work and for those of other honest labourers. 'For all worthy handicrafts and all mechanical tools he taught a reverence which he himself seemed to feel very strongly; although . . . he had never cultivated manual dexterity. He says ". . . we might but too surely lament a moral debasement, where a court dress was looked upon with more respect than a carpenter's tool-basket. The things in harmony with religion and art (not on any account confounding the two), are not fashionable follies, but tool-baskets, spades and ploughs, house-brooms, dusters, gridirons, and pudding-bags" ' (A H Palmer, p. 130).

Thus optical verisimilitude and the hard labour of art (as distinct from 'manual dexterity') became for Palmer a means of insight into the wonderful reality of the created world, a sacramental study of God's manifest purpose and universal presence.

Palmer's attitude here comes close to that of Ruskin, the origin of whose interest in art was, according to *Praeterita*, his discovery of

Turner's vignette illustrations to Rogers' *Italy*. Unlike Palmer, Ruskin was a deeply knowledgeable student of botany and geology as descriptive sciences, and he understood clearly the implications for fundamentalist religion of ideas of a dynamically continuous Creation. But between them there is the same conviction that true religion and morality were mediated by the study of the natural world, the same respect for work and contempt for facile dexterity; and there is the same remarkable coincidence in the similarity of their styles, both graphic and even literary. Ruskin in fact admired Palmer's work, though he thought that the drawings submitted for exhibition did not do him full justice. He looked to Palmer as one of the artists capable of regenerating English art through strict fidelity to Nature, and inserted a note to this effect in the later editions of *Modern Painters* I (*Works of John Ruskin*, ed. Cook and Wedderburn, 1903-12, III, pp. 604-5n.).

* Palmer refers to the use of a lens, probably a Claude glass, in 1823-4 (see A H Palmer, p. 13).

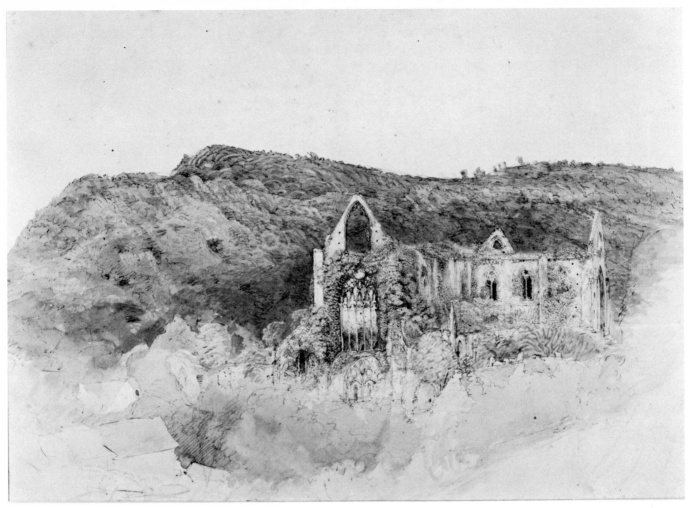

detail

39 Samuel Palmer
1805–1881
The Furze Field

Black chalk and bodycolour on cream wove;
18·9 × 27 cm.
On the back is a pencil drawing of a wooded
valley.
PROVENANCE A H Palmer; Christie's,
20 March 1909, lot 75, bt Gooden and Fox,
3½ gns; J Meyrick Head, presented to the
Museum by his widow, July 1919. P.24–1919
EXHIBITED OWCS, 1862, no. 190; Fine Art
Society, 1881, no. 95; VAM, 1926, no. 122.

Meyrick Head was a neighbour and important
patron of Palmer at Reigate. Palmer moved
to Furze Hill House in May 1862, and Head
believed that the *Furze Field* was a view of the
steep field 'where there were to be seen,
according to the season, clots of golden
blossom, masses of brakes far taller than
your head, or the blush of heather . . . one
could see above the topmost sprays, stretching
away without a break, many miles of Surrey
and Sussex; till, with the quiet gradations of
English scenery, the landscape merged in the
grey outline of the great South Downs full
thirty miles away' (A H Palmer, *Life and
Letters of Samuel Palmer*, 1892, p. 128). The
landscape sketch on the back conforms
broadly to the latter part of this description.
A H Palmer, however, told Martin Hardie in
1926 that the view was not near Furze Hill
House; he offered no alternative identification.
 Palmer's respect for Nature was not
expressed through study of natural history:
'although keenly and vigilantly observant of
so many natural phenomena, my father knew
and was content to know but little of our
native natural history. He could not have
passed the most absurdly elementary
examination in botany, entomology,
ornithology or geology' (A H Palmer, p. 130).

His interests at Reigate centred on the fields
around, and on the garden only in so far as
it could be made a refuge of natural growth
and abundance. To this end he cultivated
weeds: 'I do not think I have ever seen my
father do anything with greater care and
pleasure than, in dry summer weather, the
doling out of a little [rain] water to his
favourite "weeds". The garden had other
attractions for us than the hardly-earned
fragrance of our wild flowers, and the songs
of the birds which abounded there; for we
cut lanes in the undergrowth of the shrubs
leading unawares to tiny, sylvan arbours,
whence we could get a peep of distant
country' (ibid, p. 134).

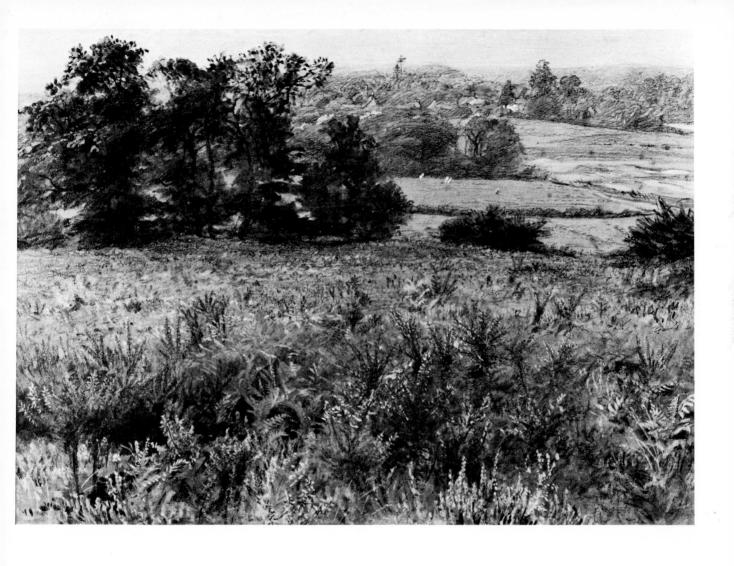

40 William Dyce
1806–1864
Goat Fell

Watercolour and bodycolour over pencil, on pale green wove; 23 × 33·9 cm.
The paper browned by exposure to light.
PROVENANCE Agnew's, from whom bought by the Museum, May 1888. 447–1888
EXHIBITED *Centenary Exhibition of the Work of William Dyce*, Aberdeen Art Gallery and Agnew's, 1964, no. 72 and p. 17.
LITERATURE Allen Staley, *The Pre-Raphaelite Landscape*, Oxford, 1973, p. 166. See also D and F Irwin, *Scottish Painters*, 1975.

Dyce visited Arran in 1859, and *Goat Fell* is assigned to that year by all authorities. The trip was undertaken primarily as a holiday from Dyce's extremely demanding official duties in London, but the work he brought back from this and similar tours in 1858 and 1860 confirmed him as a laborious open-air painter in the Pre-Raphaelite manner. His relations with Ruskin were complicated by differences over the administration of art teaching, but Ruskin broadly approved the developments in his style in the later 1850s, and paid tribute to 'an amount of toil only endurable by the boundless love and patience which are first among the Pre-Raphaelite characteristics' (*Academy Notes*, 1857, quoted from Staley, p. 164). Laborious painting of landscape was certainly present in the pictures of the following years, in which Biblical figures were introduced into Scottish and Welsh scenery. The point of this, as F G Stephens recognized, was to express the immanent holiness of the real world, and the same intention presumably lay behind the unexhibited genre subjects of women washing and knitting, and children playing, painted in Scotland and Wales in 1859–60. 'Mr Dyce is rapidly becoming a realistic artist', wrote Stephens in 1860, though he regretted that Dyce had not completed his realistic study of the historical Jesus by a visit to Palestine (Staley, p. 165).

Against this background, the *Goat Fell* takes on a particular interest. In style it recalls the coloured sketches of the Varley circle in Wales in the first decade of the century, and it emphasizes how this mode of apprehending the optical reality of vision still contributed to the technical vocabulary of realists in the mid-century. The form of the sketch, with its undefined edges and concentrated focus, is far from that of finished Pre-Raphaelite pictures of the 1850s, where the focus tends to be evenly sharp over the whole surface. Nevertheless, as the vignette sketch was important to Ruskin's discovery of holiness in the created world, so it may have fulfilled something of the same purpose for Dyce. The drawing would thus be a visualization of the opening lines from Psalm 121 – 'I will lift up mine eyes unto the hills, from whence cometh my help. My help cometh from the Lord, which made heaven and earth.' These were lines to which Englishmen of the generations of Thomas and Matthew Arnold responded with strong emotion.

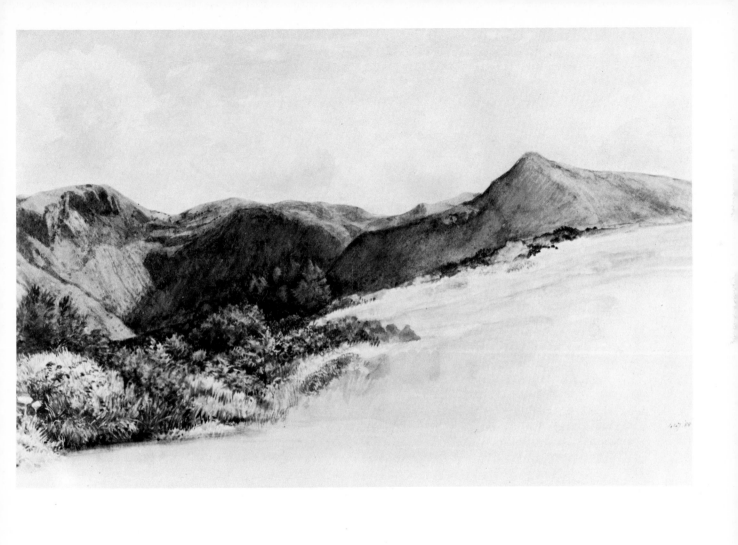

41 Sheldon Burrowes Adams
1838–1866
Trees, Foliage and Rocks by a Stream

Watercolour over faint pencil underdrawing on thick white wove; 34·5 × 45·4 cm (maximum).
The sheet cut and torn; a little engrimed. On the back are offset (?) chalk drawings of women.
Inscribed in pencil *verso*, presumably by the donor's mother or father: *1 great 2 great 3 grand 4 mother 6 generations.*
PROVENANCE By descent in the artist's family; presented by his granddaughter, Miss Elsie Gledstanes (b. 1891), in March 1968. P.54–1968

Adams was unknown until three drawings were presented to the Museum in 1968 by Miss Gledstanes, and she is the only source of information. Family tradition thus records that Adams' father did not approve of his son being a professional artist, and had bought him a commission in the army just before he (the son) died of typhoid in 1866. Apparently Adams had been able to charge £50 for finished watercolours, but nothing that could have commanded such an enormous price is now known, and there is no record of any contributions to the exhibitions. He seems to have married in about 1862–3, and lived thereafter in North Wales. He is said to have been working on one of the drawings now in the VAM – going to dip his paper in the stream, when he missed his footing and fell in – just before he caught typhoid. The assumption must be that the present drawing was one of his last works, left fragmentary and unfinished in the studio, and similarly painted out of doors.

It is in fact much the most interesting of the three: the others being more or less routine Welsh drawings, distantly influenced by Cox or Müller. Adams' promise is clear from the *Trees, Foliage and Rocks*, and it seems probable that he had become aware of Pre-Raphaelitism, perhaps through seeing exhibited works of Millais such as *Ophelia* (RA, 1852), or from reading Ruskin, or F G Stephens in the *Athenaeum*. The subject is finished piece by piece, presumably on the spot, but curiously it is not botanically very precise. There seems to be less effort to differentiate between types of grass and fern, or between bramble and alder leaves, than to work out a satisfying flat pattern of colour and shape. That said, however, the drawing is clearly a fragment of a larger work in the context of which the completed passages would have seemed impressively detailed. On this level it shows Adams' talent at its best, and how he might have produced watercolours in the £50 range. It also shows how pervasive the influence of Pre-Raphaelitism was in provincial Britain even by the sixties, and what an invigorating effect it had on the draughtsmanship and colour-sense of artists.

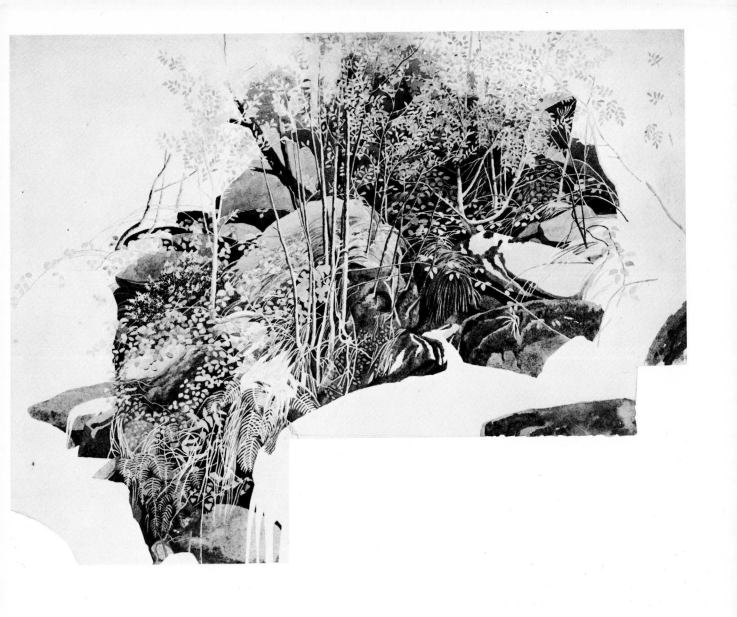

42 J W Inchbold
1830–1888
Above Montreux

Watercolour and bodycolour, sponged and
cut, on white wove, put down on card;
whole sheet 35·7 × 53·6 cm (irregular);
painted area, 31·7 × 52·2 cm approx.
Torn at the edges.
Signed with the brush in brown lower left:
I. W. Inchbold./Montreux. 188[o? – last figure
illegible].
PROVENANCE Sir A H Church (1834–1915);
presented to the Museum by his widow in
fulfilment of his wishes, August 1915.
P.18–1915
LITERATURE Allen Staley, *The Pre-Raphaelite
Landscape*, Oxford, 1973, p. 122.

Inchbold was one of the young artists taken
up by Ruskin in the 1850s, when he was
working on the last volumes of his defence of
Turner in *Modern Painters*, and turning
also to the active championship of
Pre-Raphaelitism. Ruskin must have
encouraged Inchbold to visit Switzerland and
the Alps, but, unlike Brett, Inchbold seems
to have avoided making studies of rocks.
This, or a temperamental incompatibility,
may account for Ruskin's disappointment in
his protégé, but even so it is difficult to
understand the rift between them. Inchbold's
appeal to connoisseurs of both rocks and
pictures is attested by the fact that *Above
Montreux* belonged to Sir Arthur Church,
a President of the Mineralogical Society, and,
like Ruskin, a collector of petrological
specimens. *Above Montreux*, also, is a fine
demonstration of synthesis between the
apparently conflicting tendencies of Turner's
art and of Pre-Raphaelitism. Though Turner's
late watercolours were not widely known
among artists in the 1850s, Inchbold probably
had an opportunity of seeing Ruskin's

collection, and to the end of his life, as in the
present drawing, he imitated Turner's mode
of signature. But Inchbold had little of his
master's imaginative responsiveness to motif:
the steamboats on the lake, the Castle of
Chillon in the middle distance, the figures in
the foreground, are related thematically
neither to one another nor to an intellectual
scheme for the picture as a whole. They are
parts of a view that offers the illusion of
actuality, a view seen and memorized at a
particular moment, and reproduced as a
pictorial surrogate of the original.

Ruskin's reviews of the annual Watercolour
Society exhibitions provided support for such
a concept of landscape art, and similar
intentions lay behind some of the pure
landscape of the Pre-Raphaelites and their
followers. It seems likely that Inchbold kept
closely in touch with the exhibited work of
Holman Hunt in the sixties and seventies.
The angular, 'naïve' drawing of the figures in
Montreux, the surprising and compositionally
unconventional street scene to the left, and
the use of the bare branches of the tree to
link the high foreground to the inferior
distance, are all strongly reminiscent of Hunt's
realistic landscapes from his Palestinian
travels.

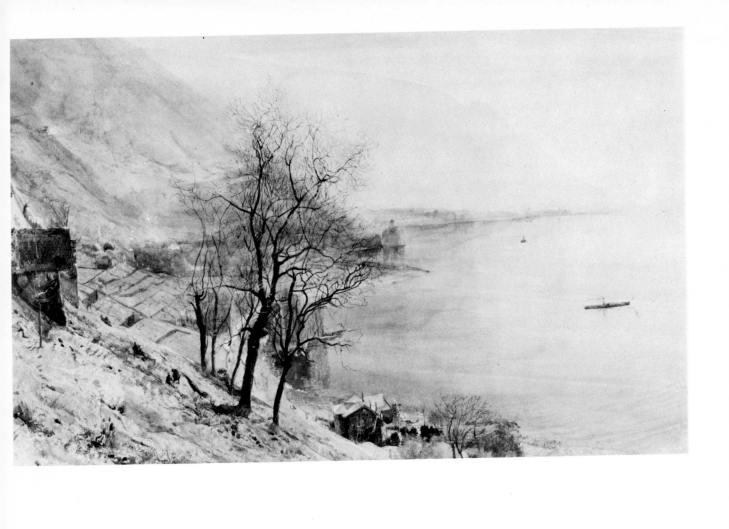